Assassinated Beauty

Assassinated Beauty

Photographs of Manic Street Preachers

Kevin Cummins

FABER & FABER

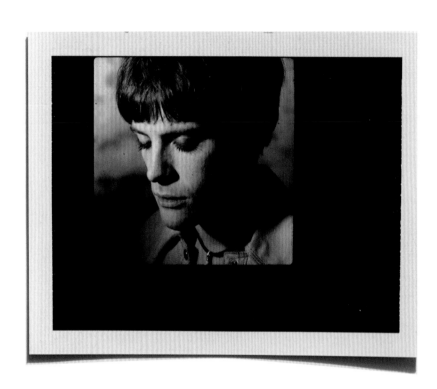

Foreword
Michael Sheen

I first became aware of the Manics when I saw them on *Top of the Pops* wearing balaclavas during their 'terrorist chic' period. At the time, I felt like I'd missed out somehow because I was too young for punk. It made me feel guilty, that somehow I wasn't a proper teenager because I'd never been a punk. So when I saw Manic Street Preachers on *Top of the Pops*, they just jumped out at me. They seemed so sure of themselves; so confident. The more I discovered about them, the more I liked them. Their political consciousness was reminiscent of the seventies ska movement – The Specials especially. Then there was the glam make-up, the gender ambiguity, with the anarchic edge of punk. So they had everything I'd grown up with all in one package . . . and they were Welsh.

There were probably only four people in Newport who were into the things the Manics were into so of course they had to become a band. They were naturally drawn to one another. I've always been interested in philosophy and iconic figures within politics, but coming from Port Talbot I didn't know anybody else who was into that. So when I started to get to know this band who came from a tough working-class area and yet had a gender-confrontational thing going on – trashy, provocative and sexual – at the same time as having a political consciousness and an awareness of iconoclastic style, they filled that gap for me immeasurably.

It's extraordinary when you look at some of the early pictures in this book where Nicky and Richey are obviously doing what they'd always dreamt of doing. That awareness of the image, of how you engage with the camera. And you can see Sean and James watching, admiring. But there's always something slightly isolated about Richey. There's already something that's both incredibly present and absent about him in terms of his relationship with the rest of the band. Presumably that dialogue between the other three and him became even more intense after Richey disappeared.

It was years before I met them. I remember walking down Chiswick High Street when I was back from America for a few days. It was St David's Day and I had my young daughter with me. As I walked along, I heard a voice behind me going, 'Oi, Sheeny,' and I turned around and it was James Dean Bradfield. It seemed perfect that it was St David's Day. I had a quick chat

with James and then we carried on, and I remember feeling incredibly proud to be able to say to my daughter, 'That's a rock star.' That was a big moment. For years and years, I misunderstood the lyrics for 'A Design for Life'. It had such a huge emotional impact on me because of what had gone on with Richey, who you could say was designed for death. I remember once driving back to London from Wales, and as I crossed the Severn Bridge 'A Design for Life' was playing and I was just weeping. It's ridiculously nationalistic, but there was something so incredibly moving about that song, and the meaning that it had for me and particularly crossing the Severn Bridge to leave Wales. That just cemented my relationship with the Manics. At that point they went very deep into me.

When I did *The Passion* in Port Talbot at the beginning of 2011, it was so perfect that the Manics were a part of it, because everything they represented was what I was trying to do in that production. The naivety of it. The awareness of boundaries between performers and audience and stripping this down into something communal, something that is connected both to the past and traditions but also looking ahead to the future. Standing up for something and saying you have to fight for it. And the moment when the Manics came out to perform – it's bringing me to tears, I'm welling up thinking about it . . . for the curtains to go back in the working men's club and for them to start playing – I'll never forget it.

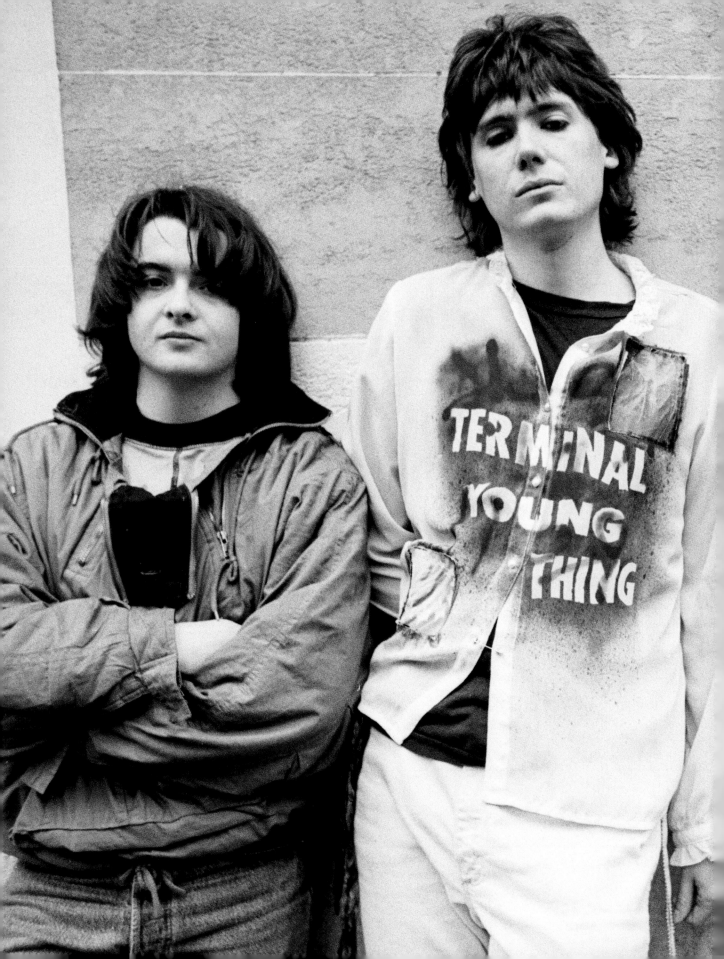

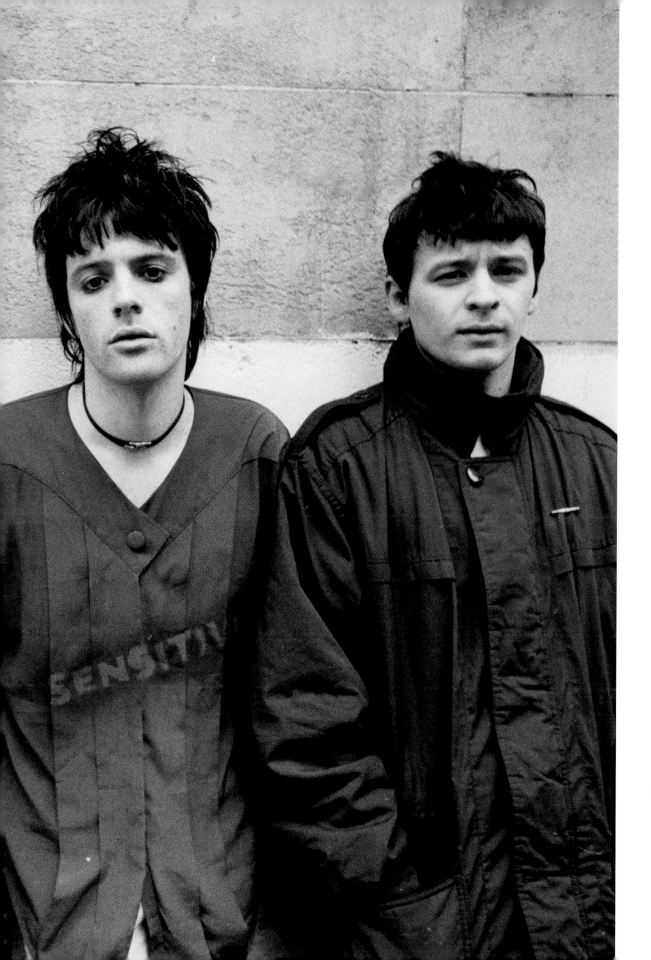

4

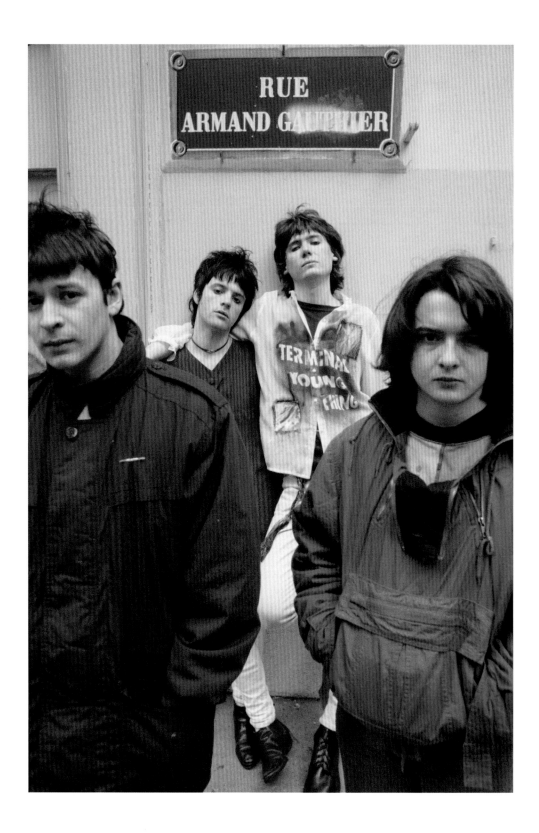

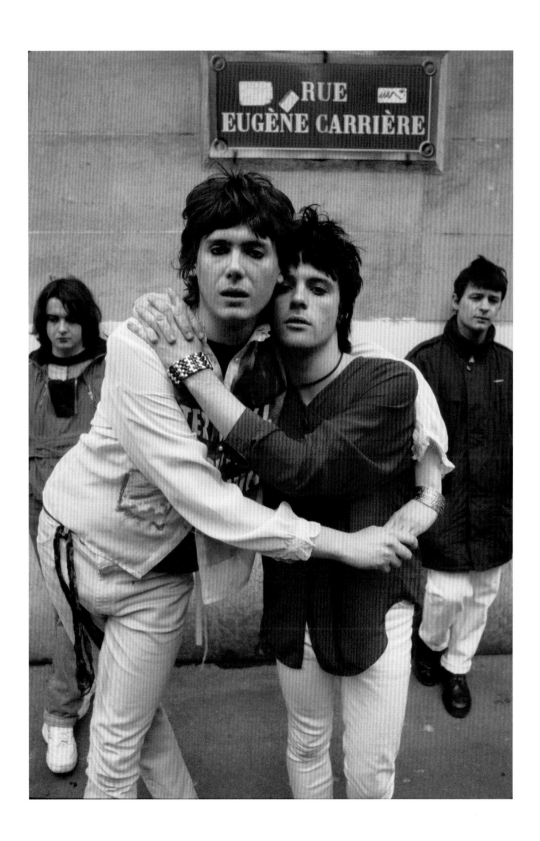

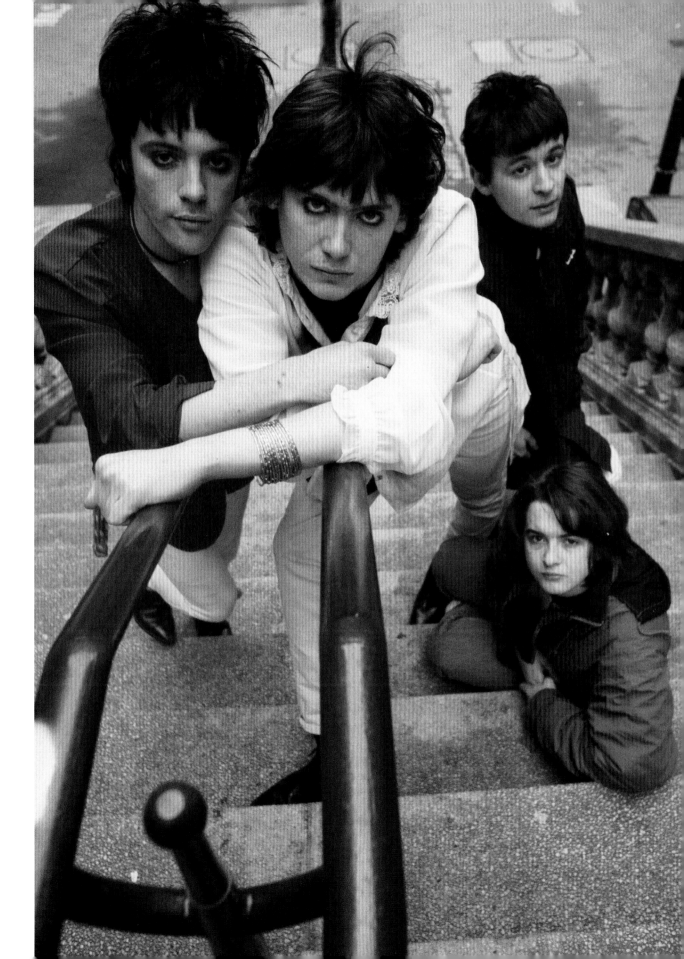

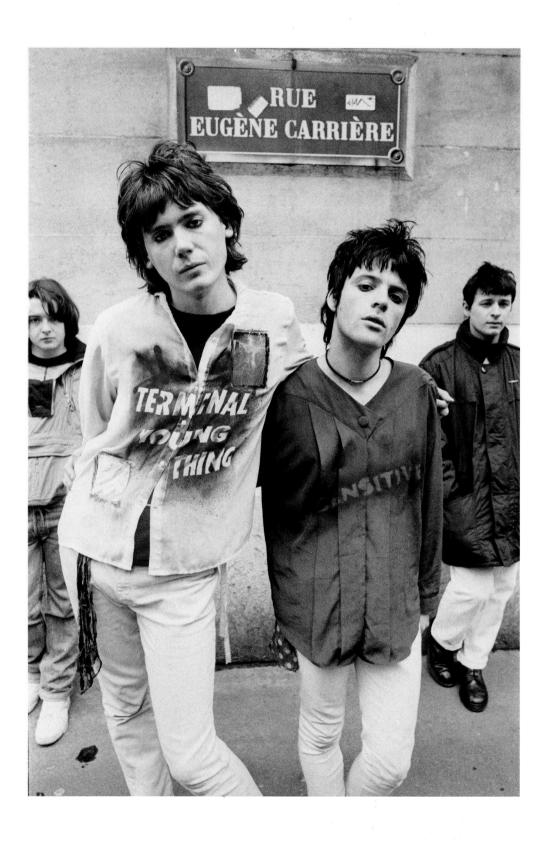

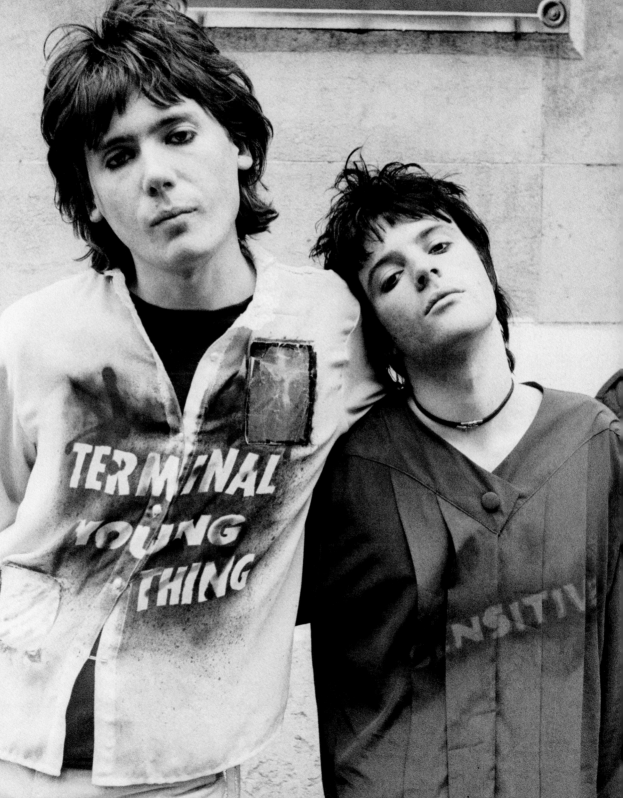

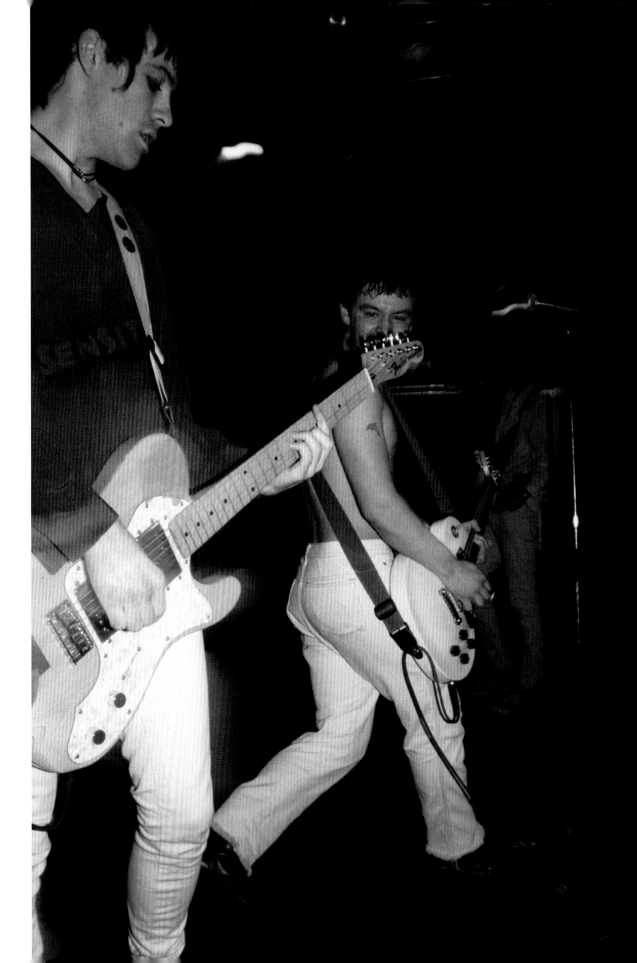

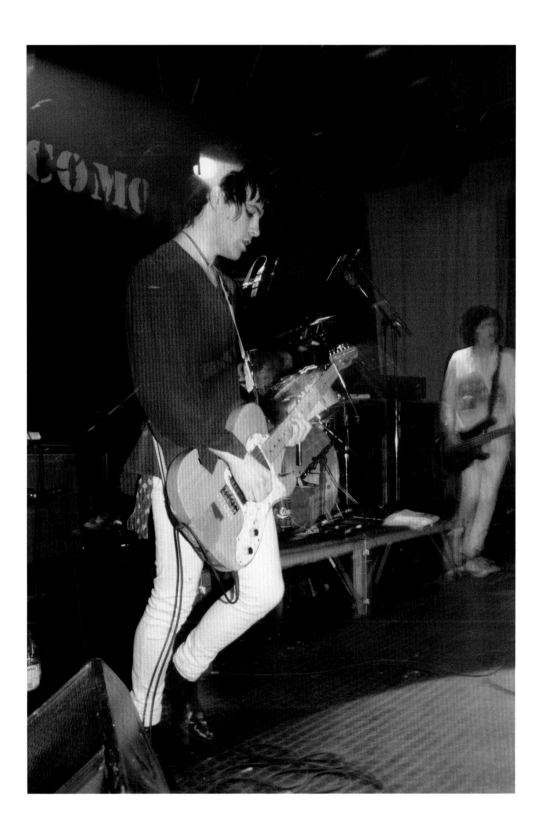

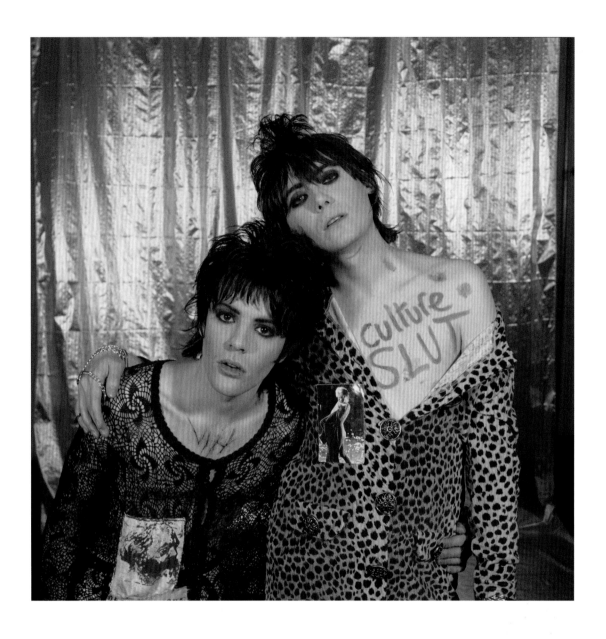

ALL YOU EVER GAVE ME GAVE ME was the boredom I suffocate in

Motown Junk

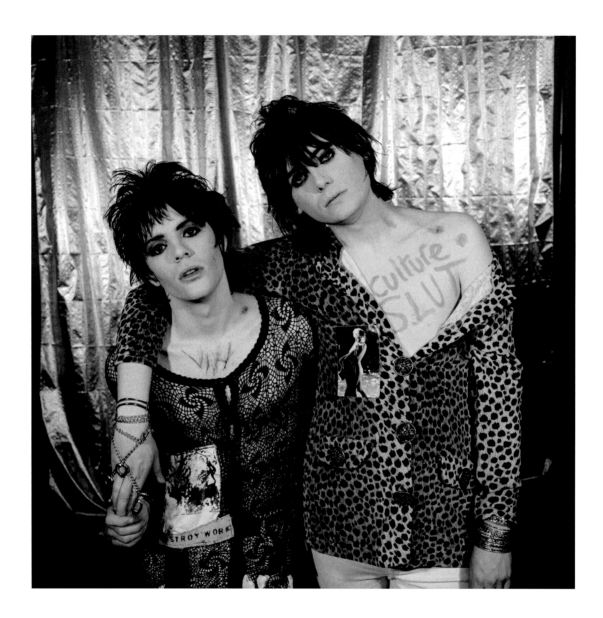

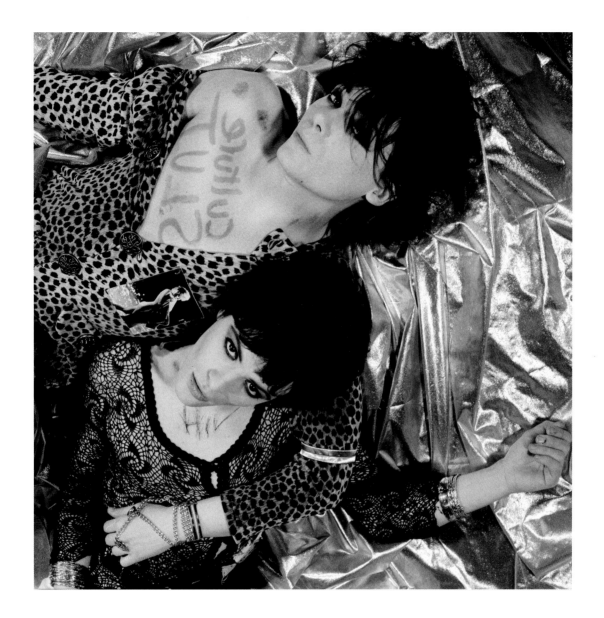

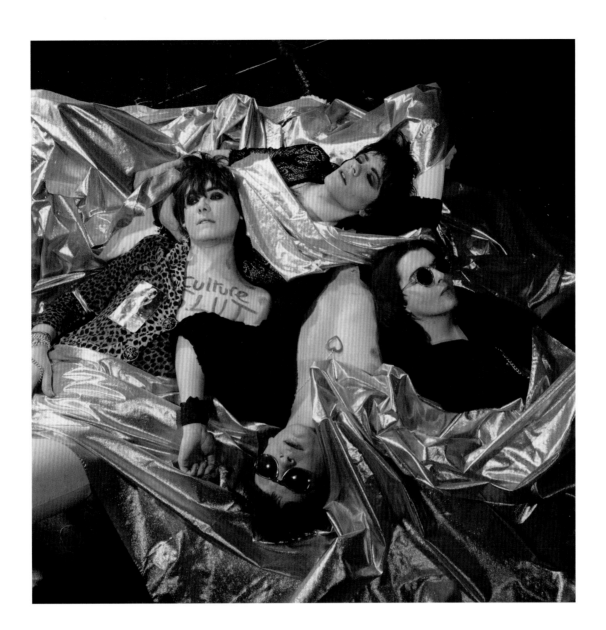

I KNEW I BELONGED

**to the public and to the world,
not because I was talented
or even beautiful, but because**

I had never belonged

to anything or anyone ever

Marilyn Monroe

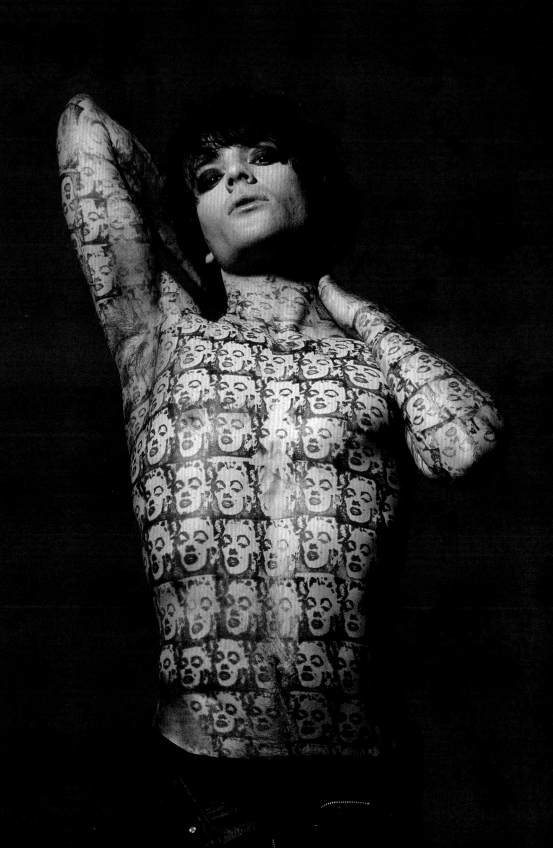

KC 230992B

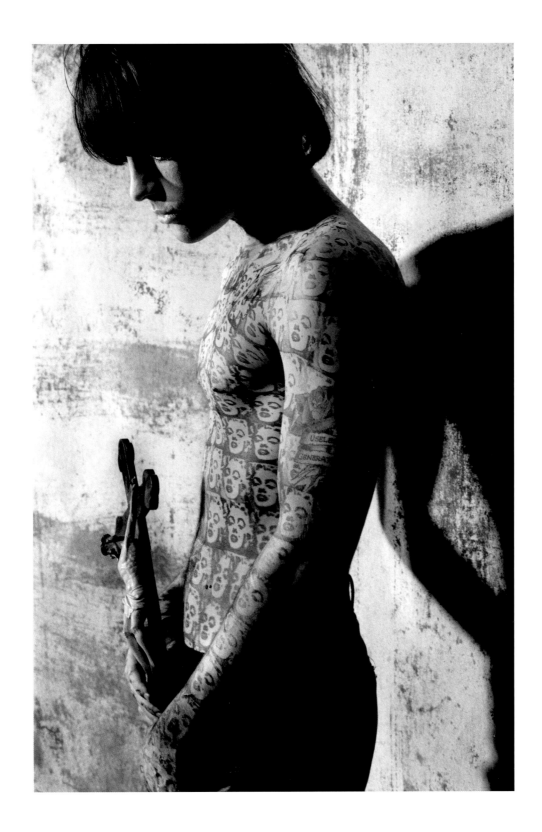

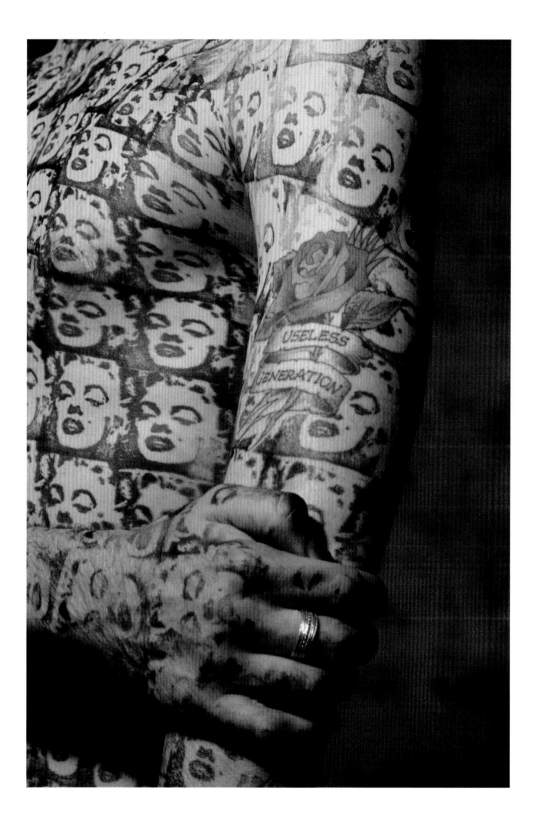

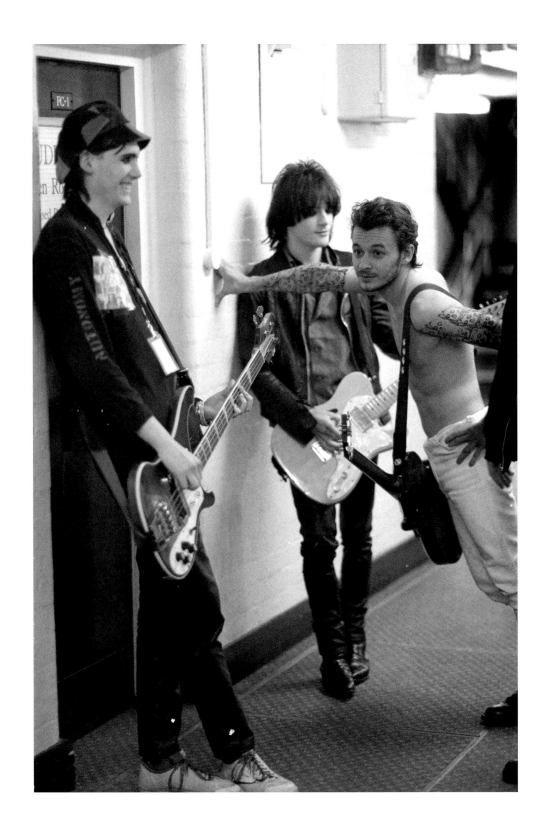

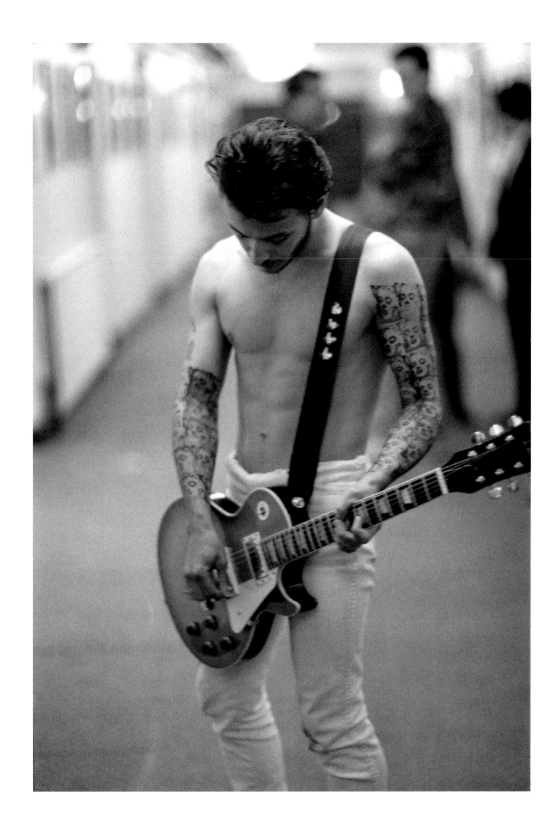

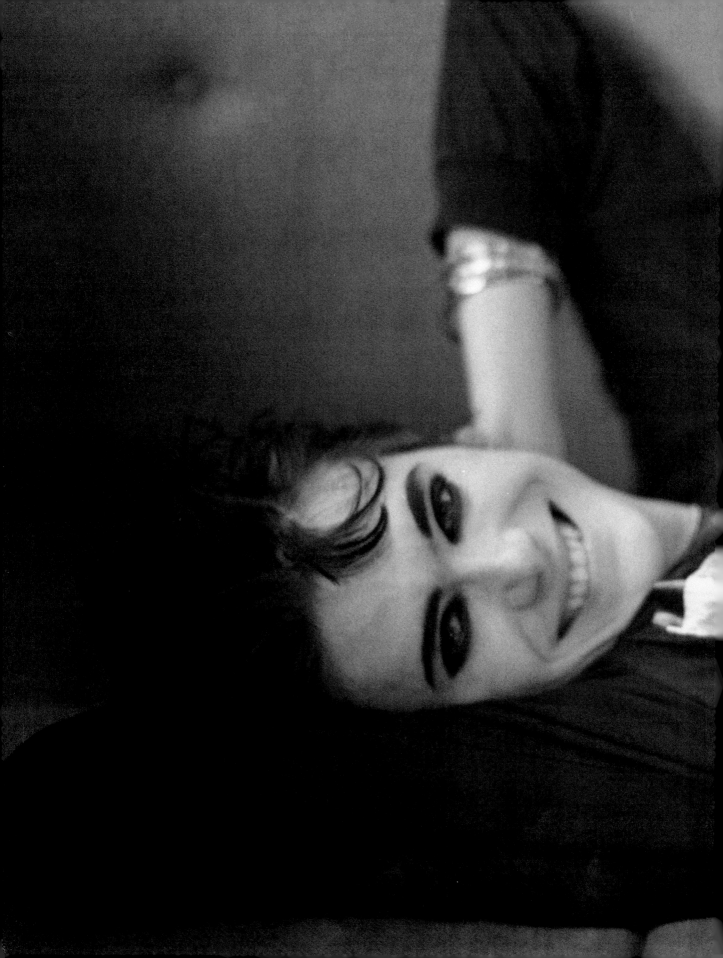

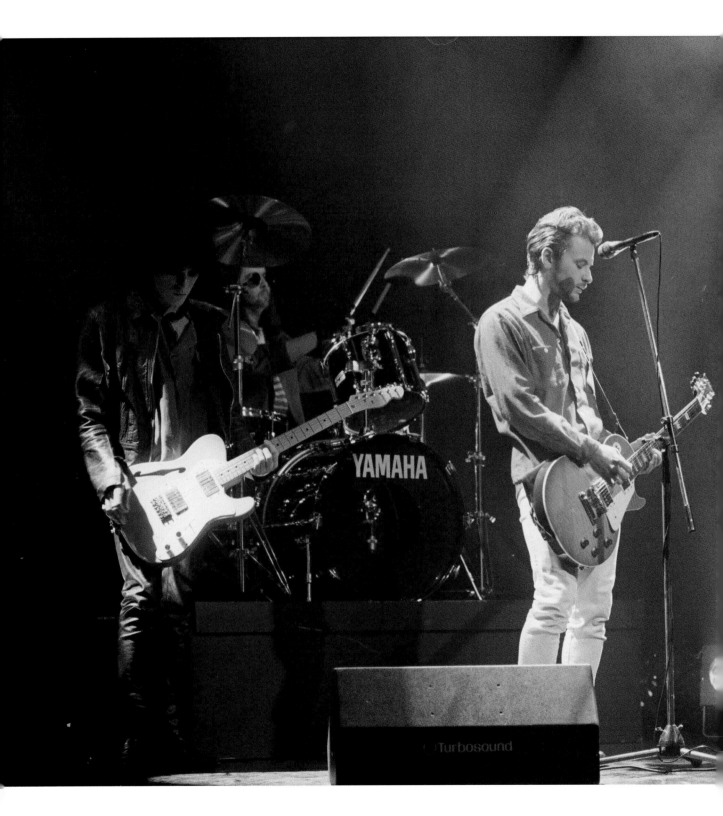

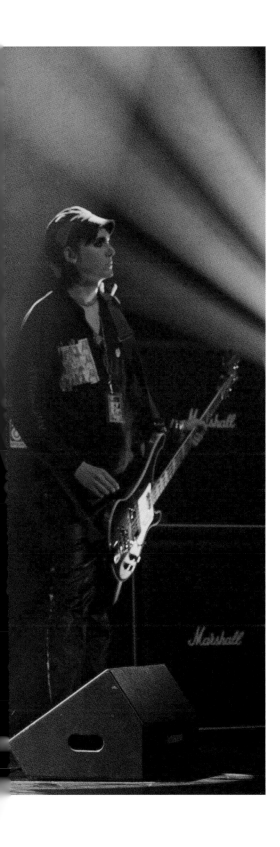

I am

NOTHING

and should be

EVERY
THING

Karl Marx

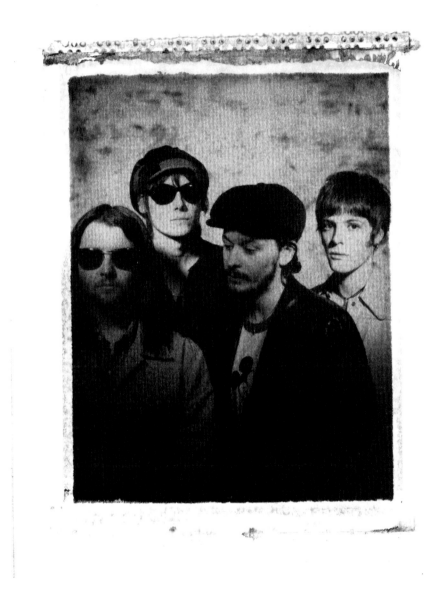

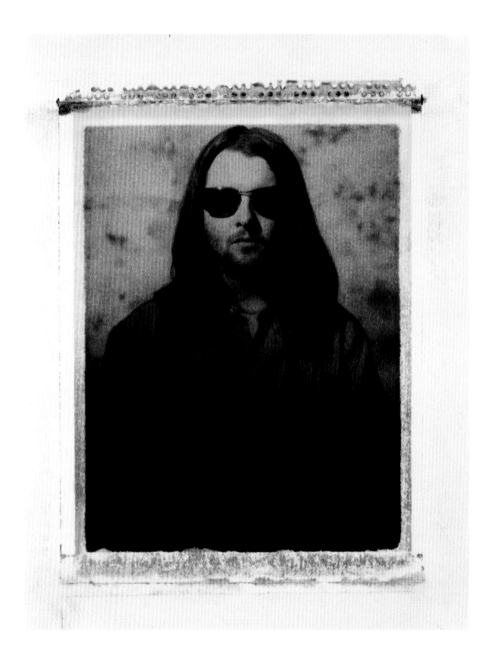

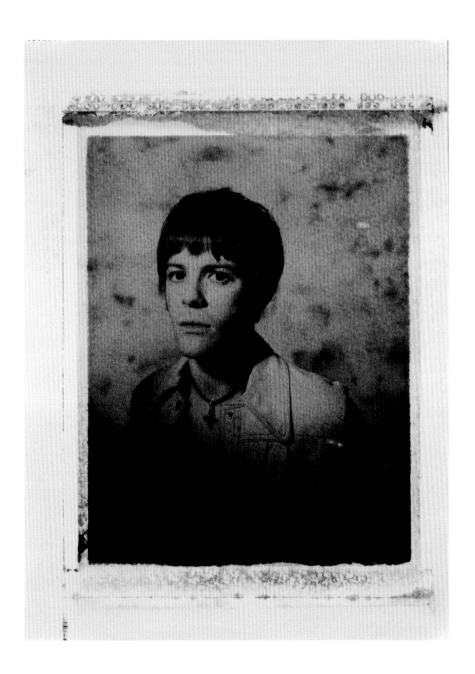

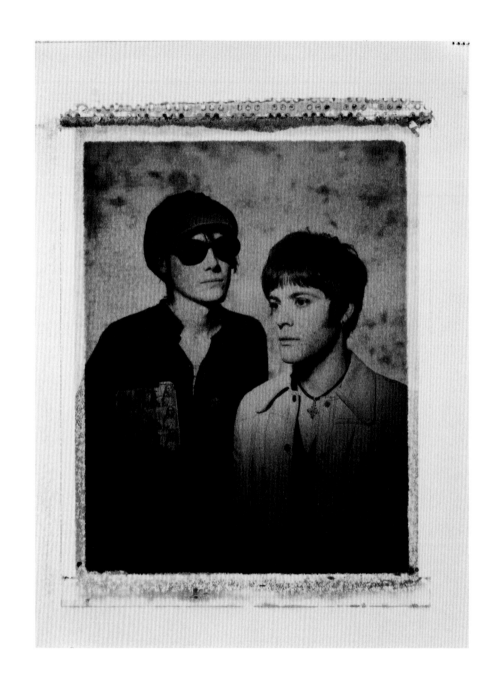

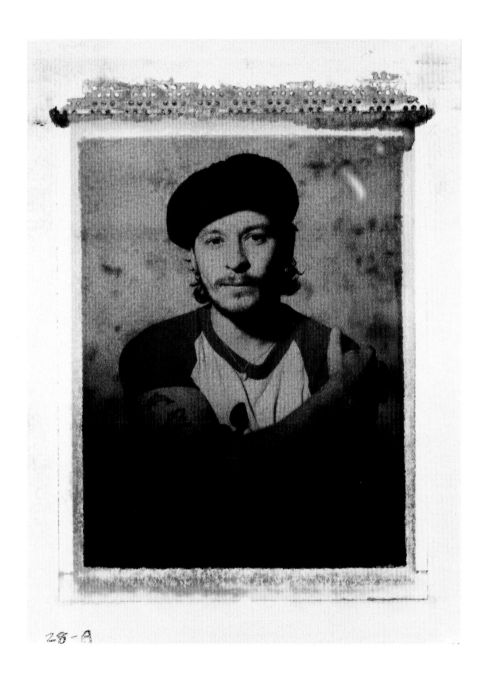

28-A

36

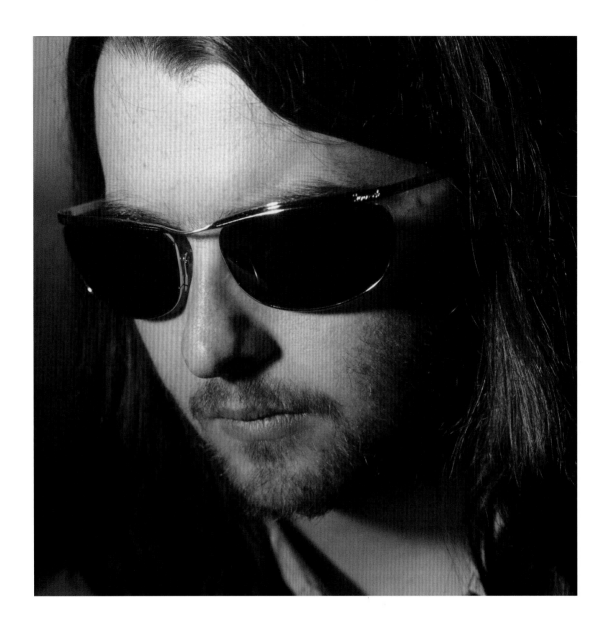

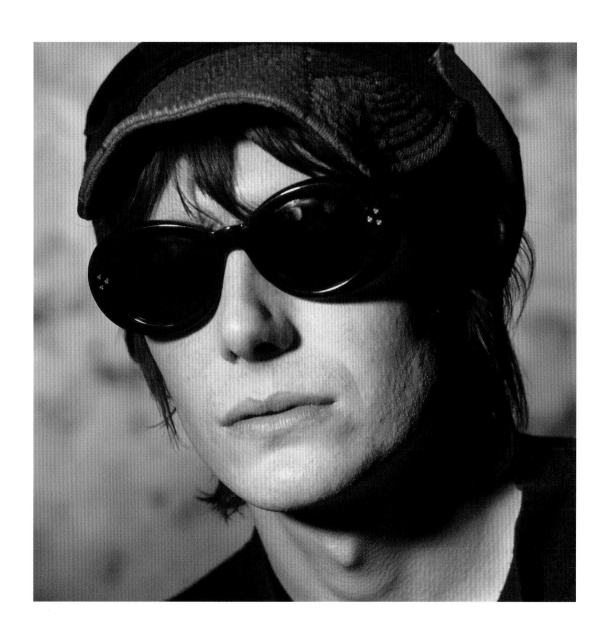

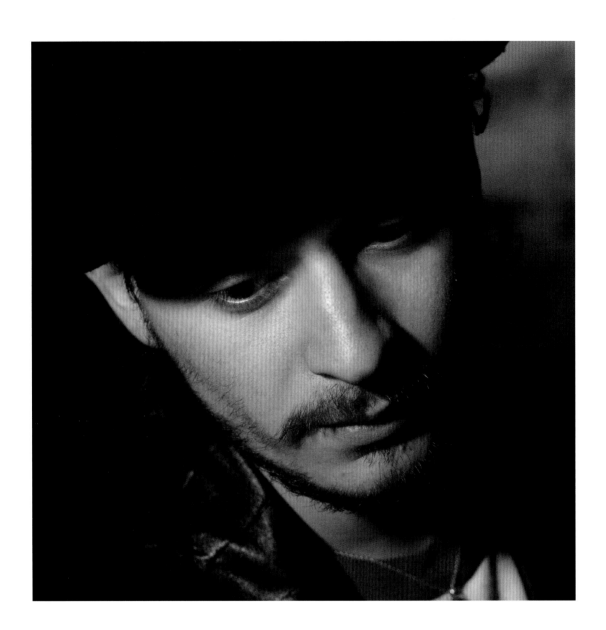

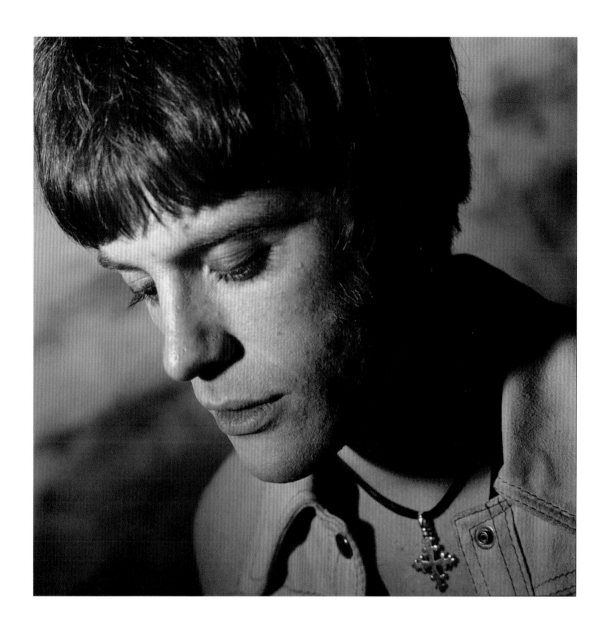

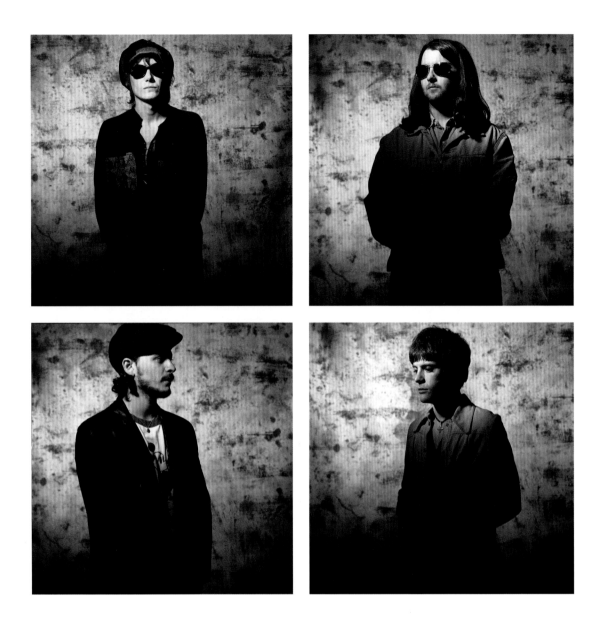

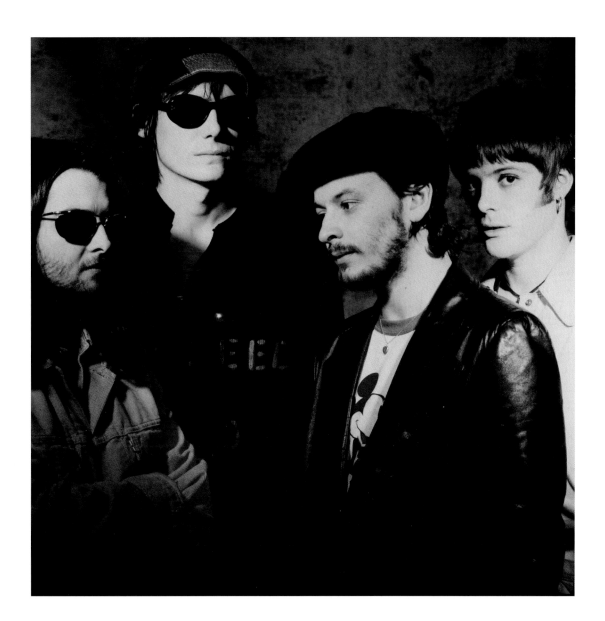

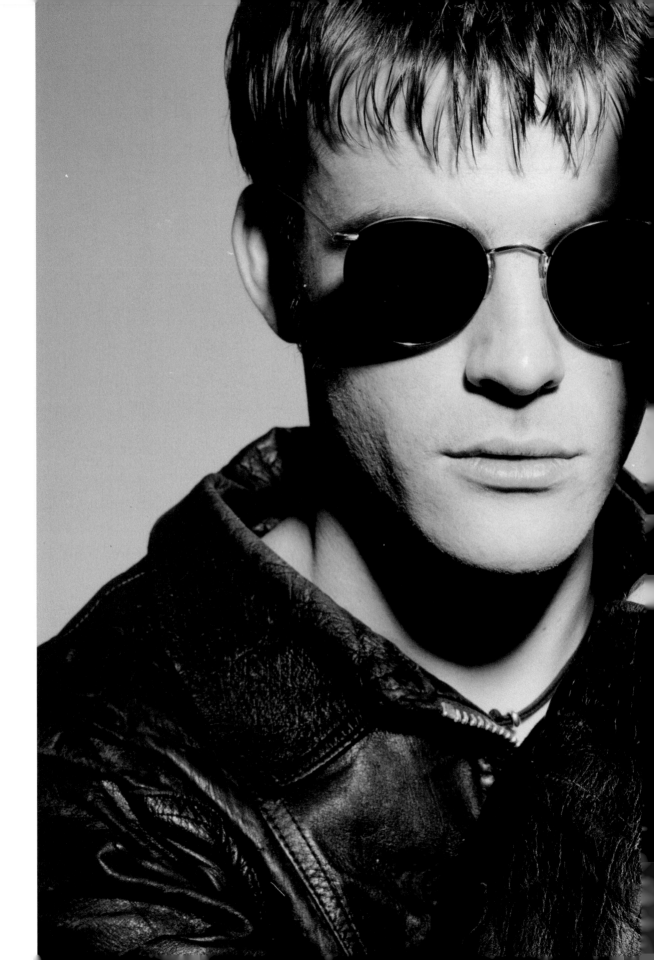

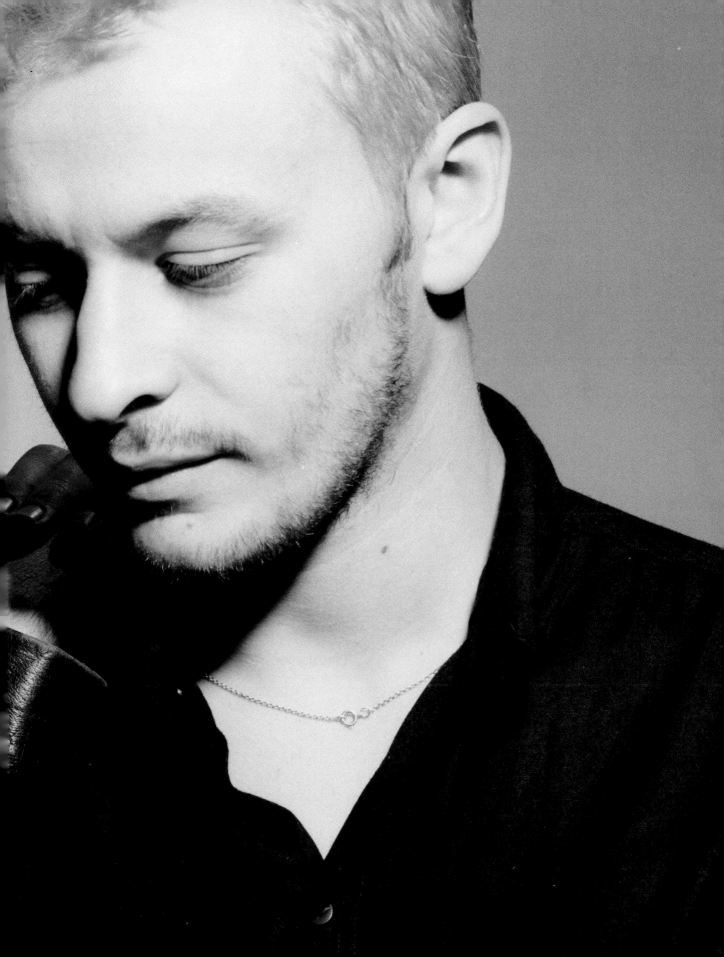

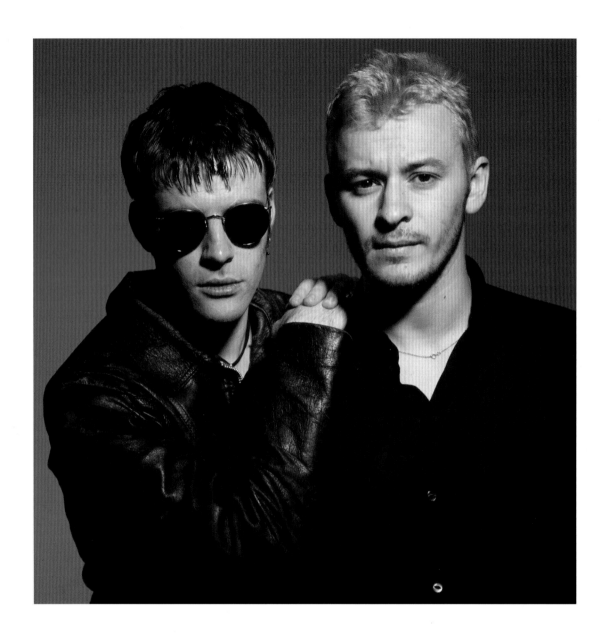

OUR LIFE IS

FRITTERED AWAY

BY DETAIL

SIMPLIFY, SIMPLIFY

Henry David Thoreau

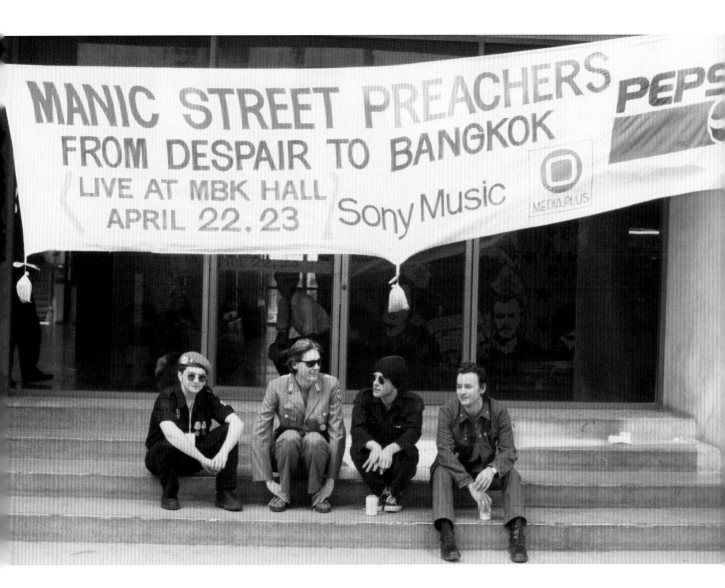

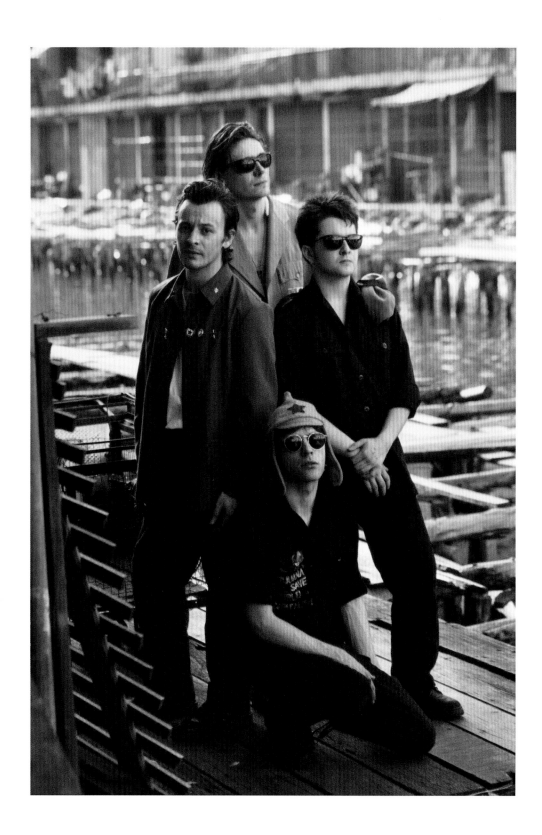

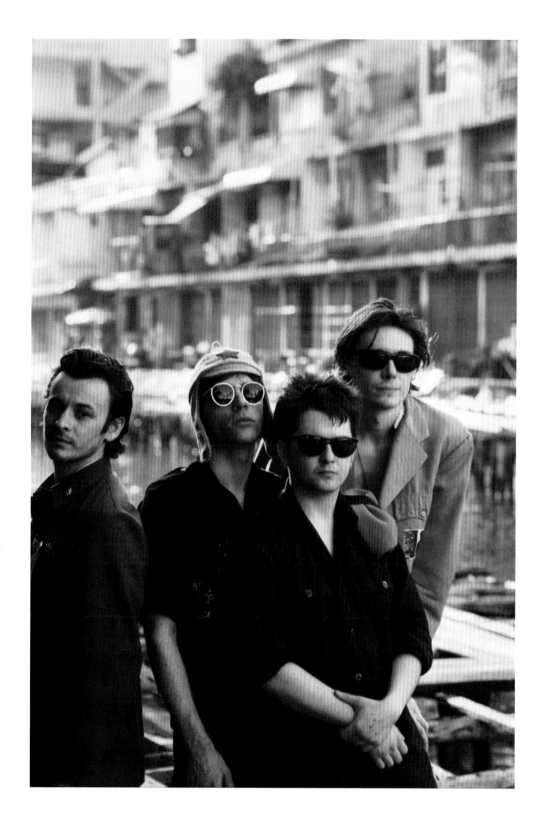

GREAT ARTISTS HAVE NO COUNTRY

Alfred de Musset

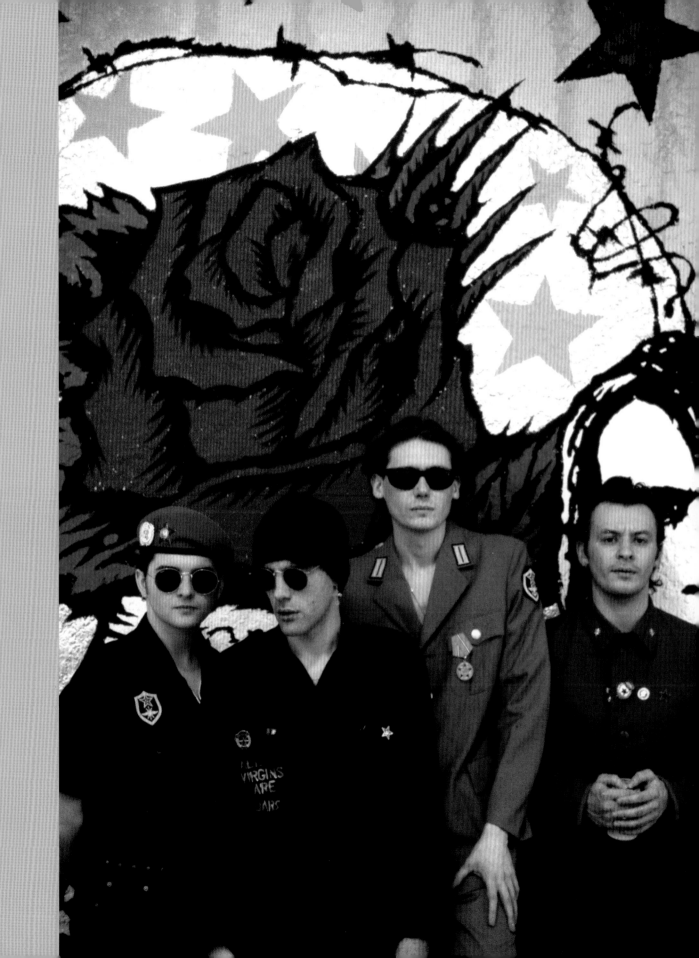

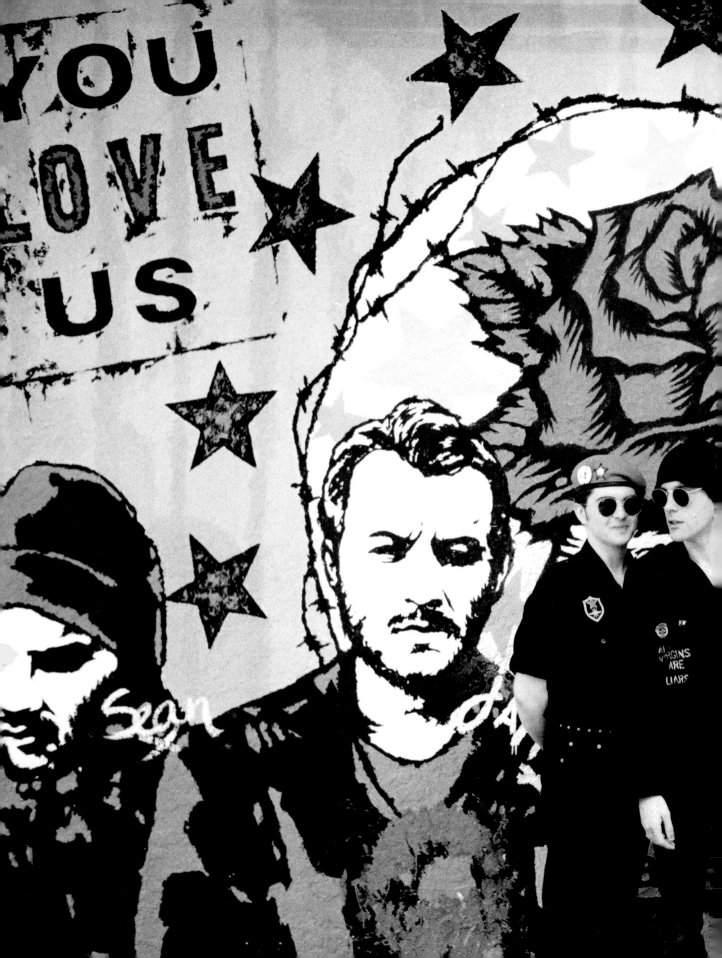

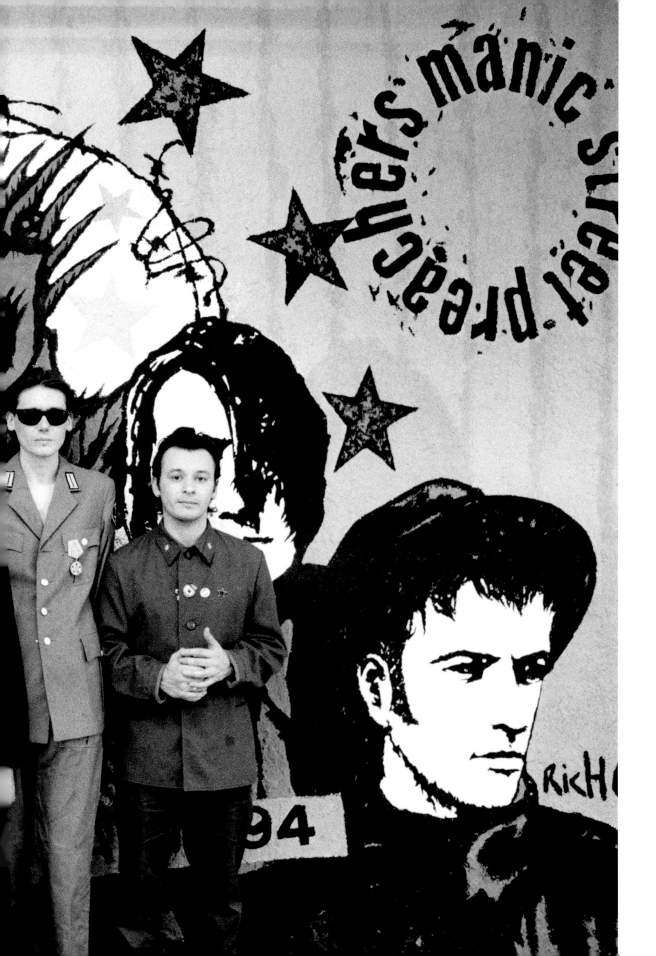

54

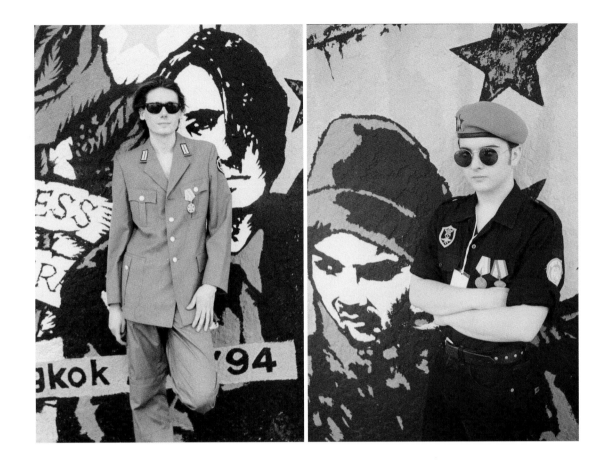

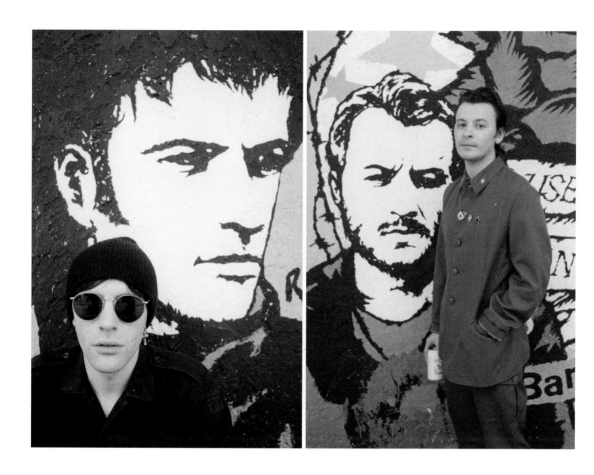

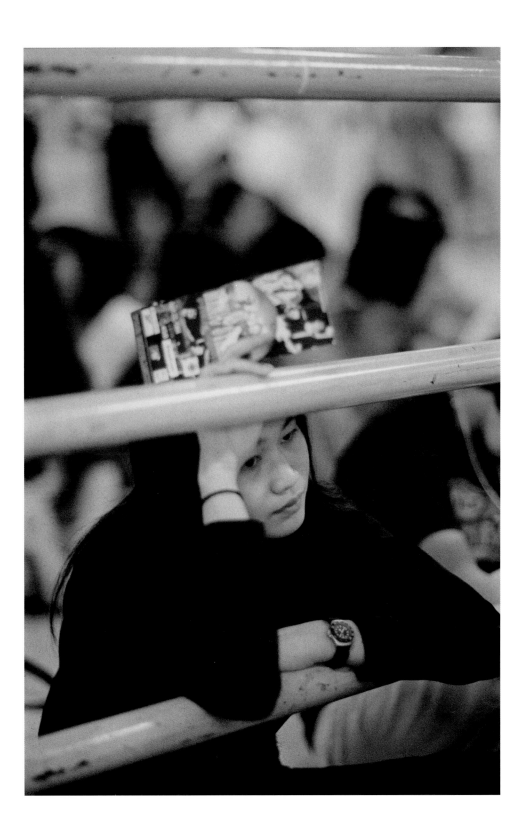

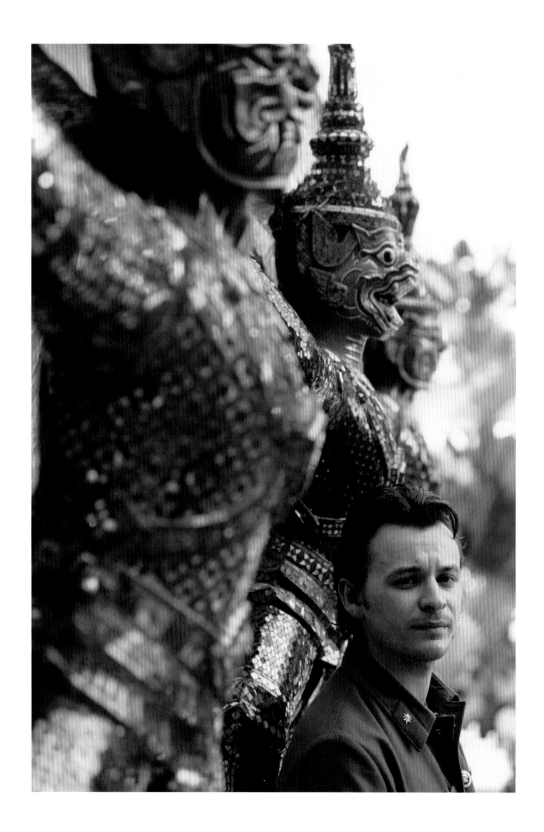

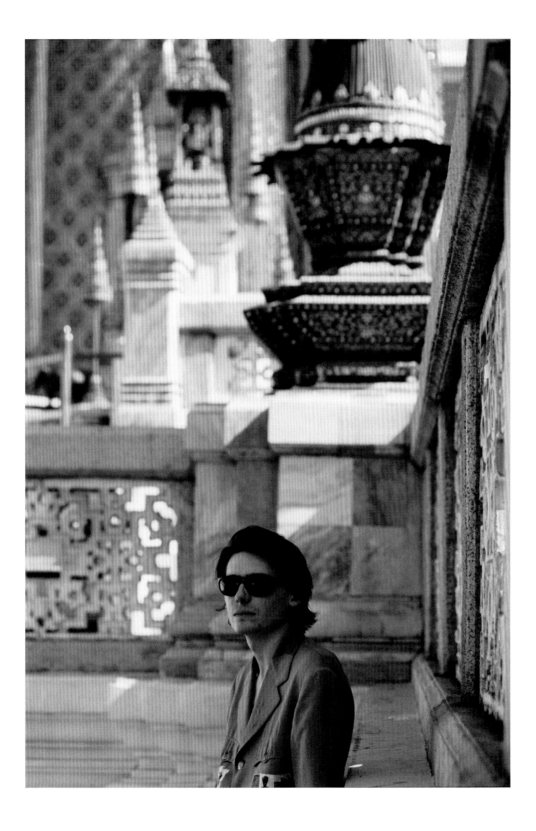

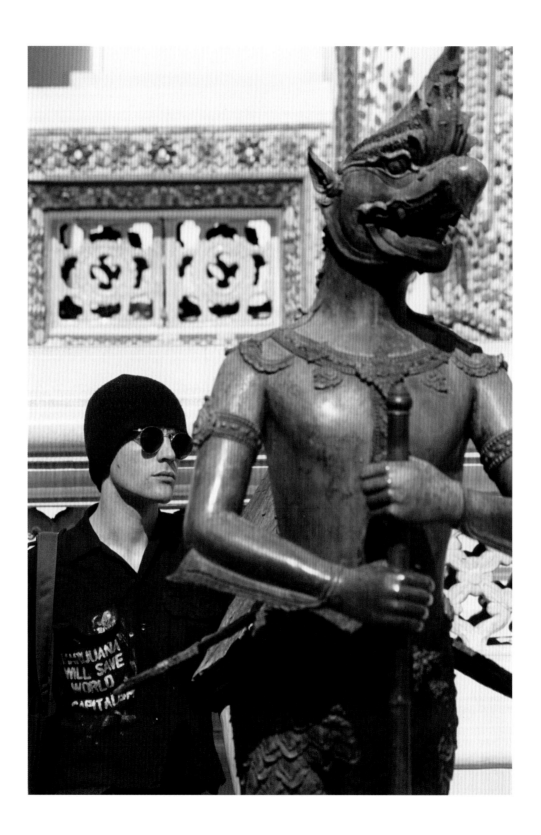

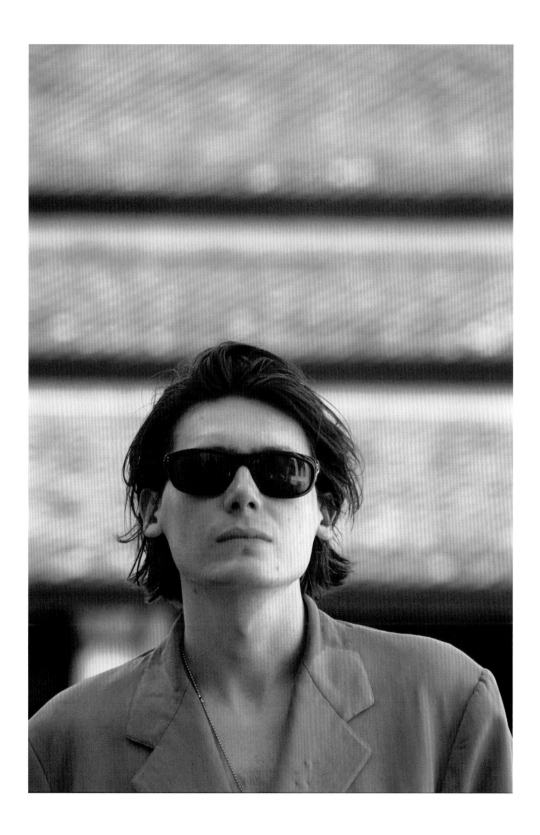

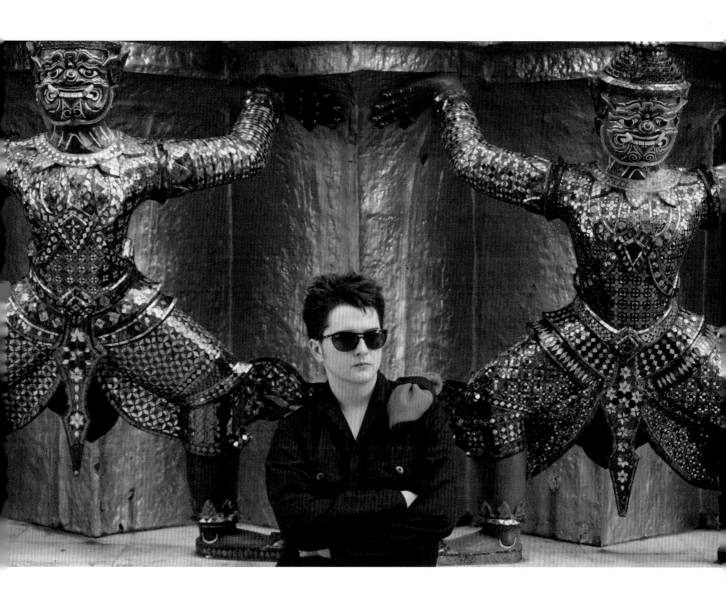

M
M
M
M
I AM STRONGER THAN
MENSA,
MILLER AND
MAILER.
I SPAT OUT
PLATH AND
PINTER
P
P
P
P
P
P
P
P

Faster

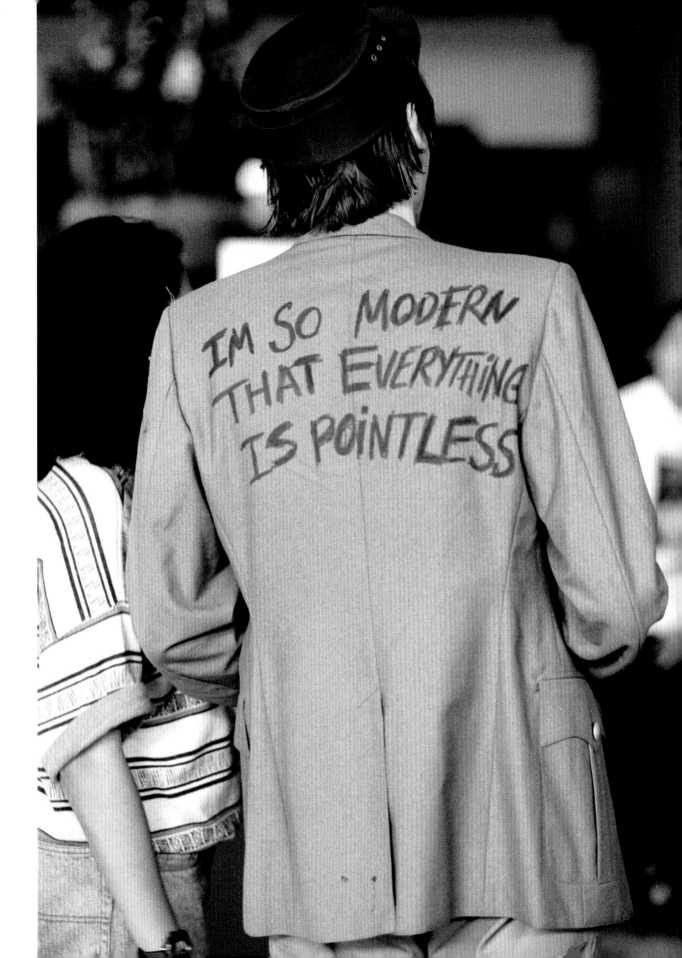

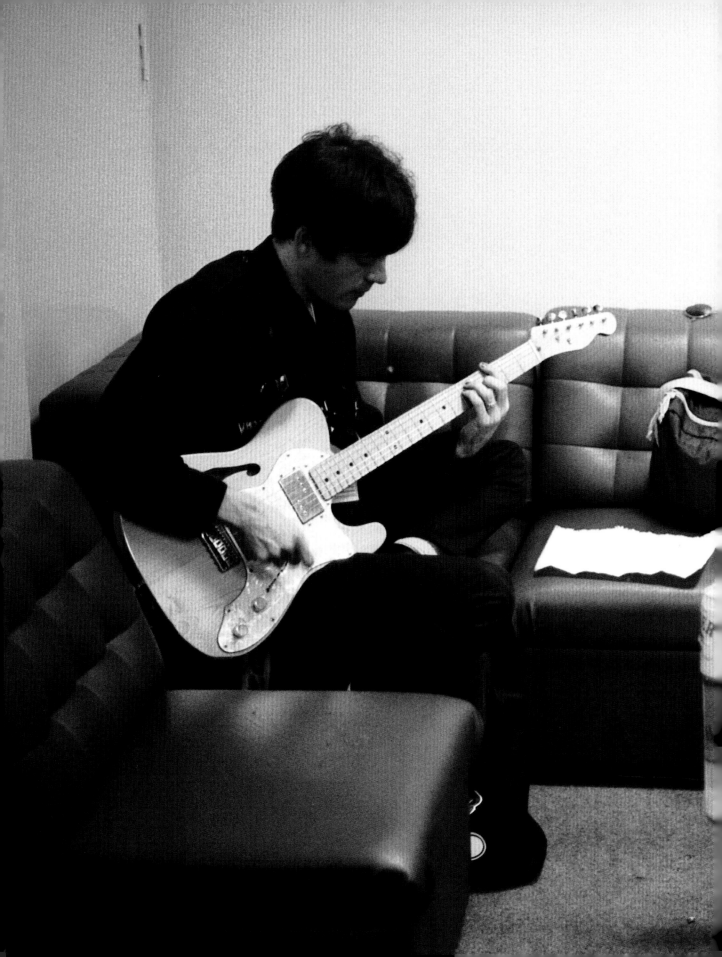

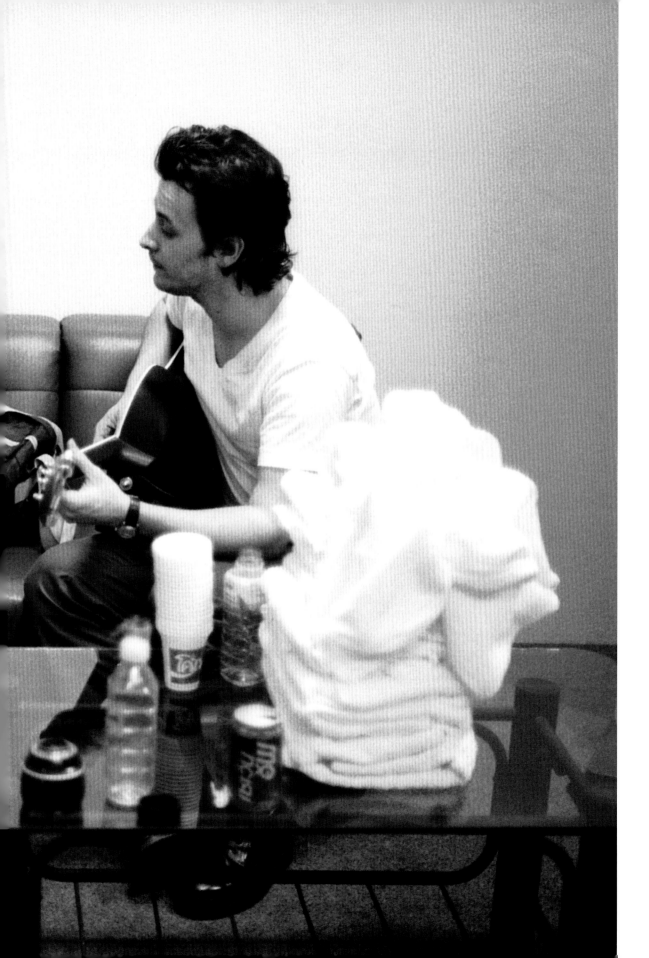

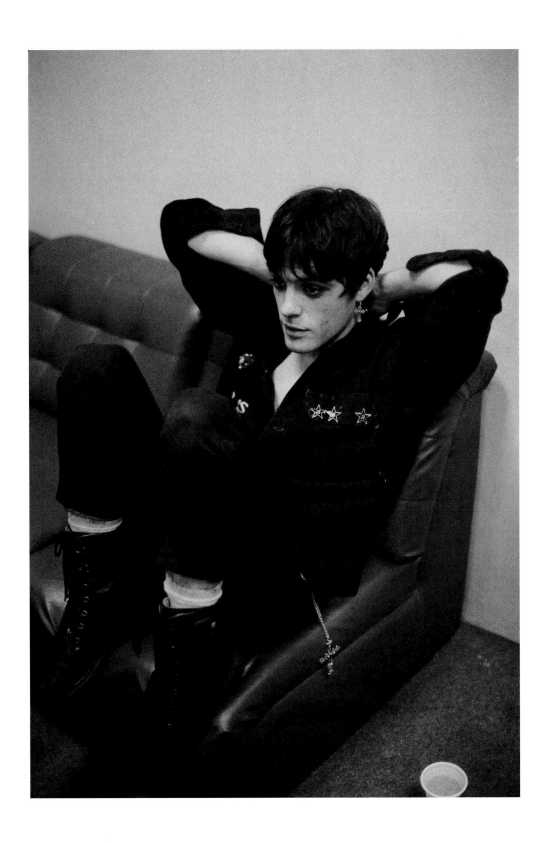

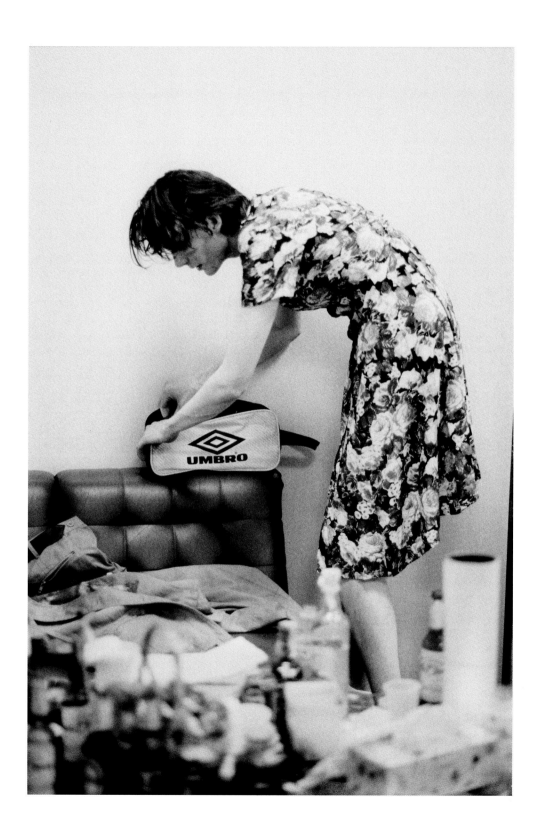

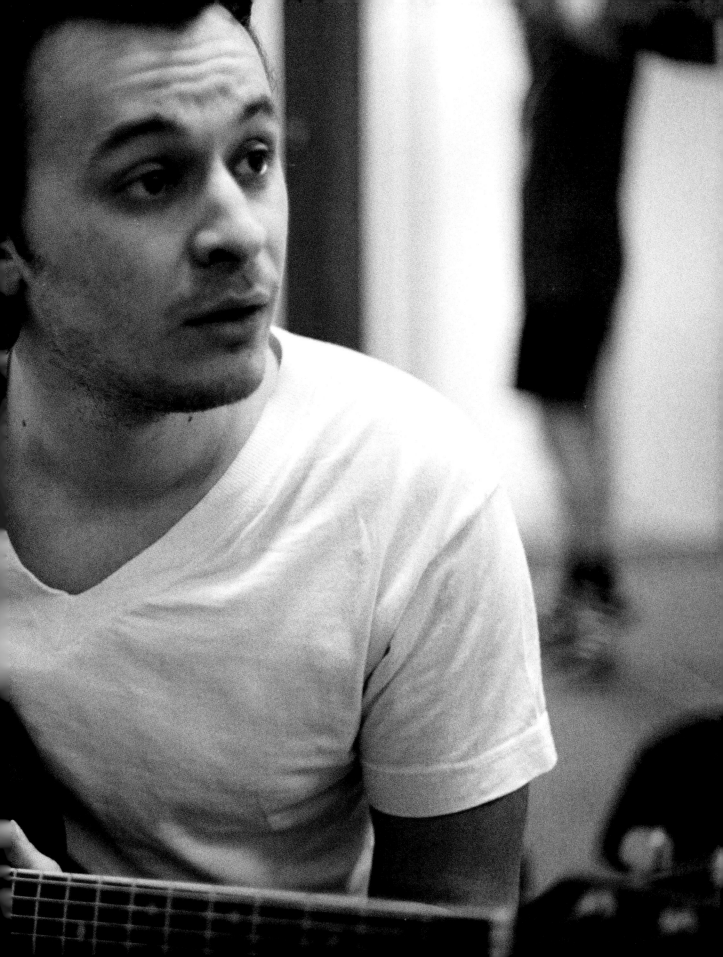

Conquer
yourself
rather
than
the
world

René Descartes

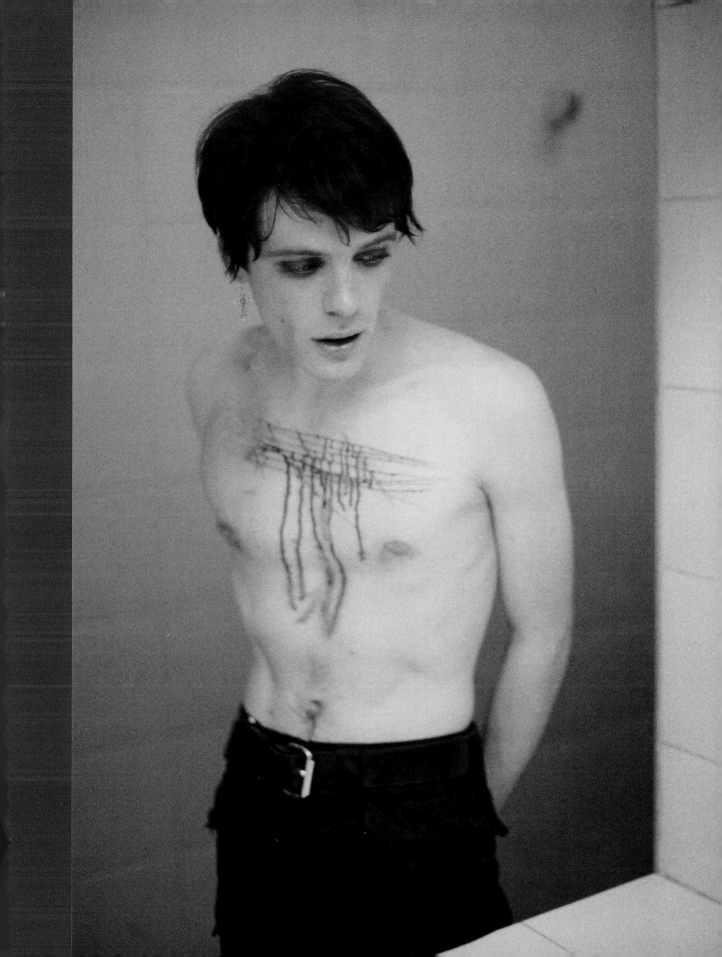

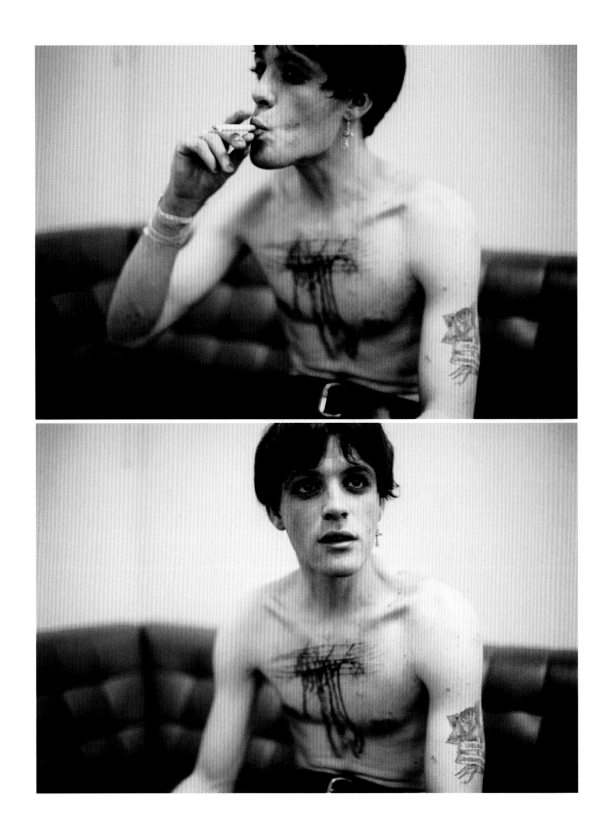

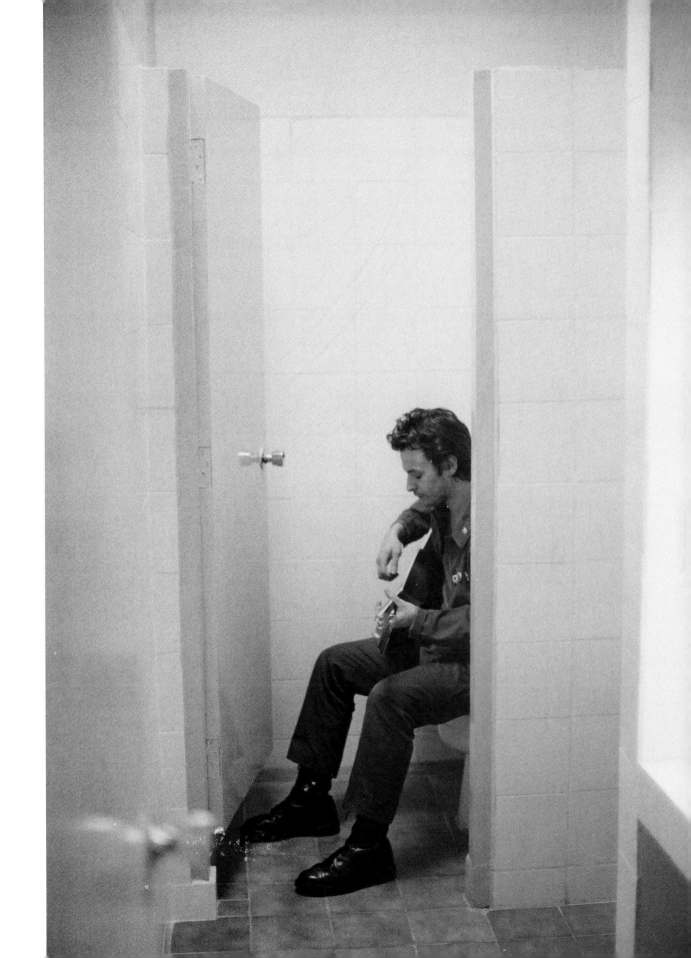

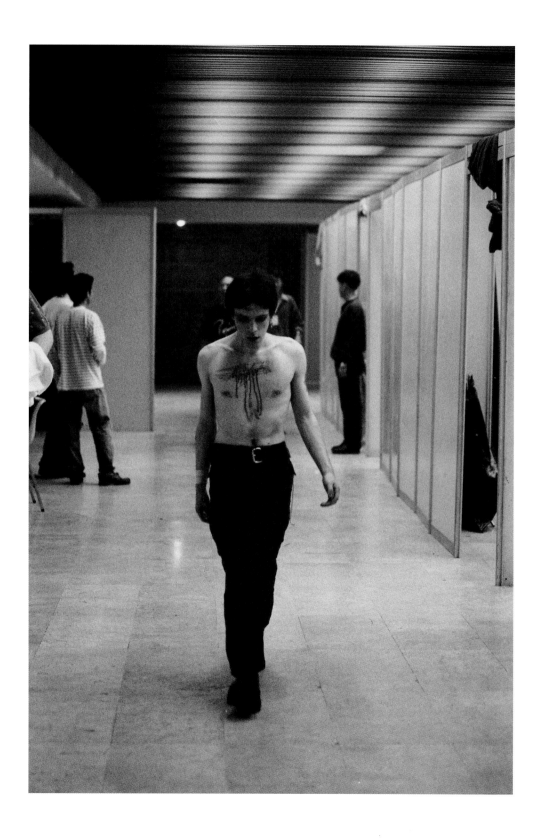

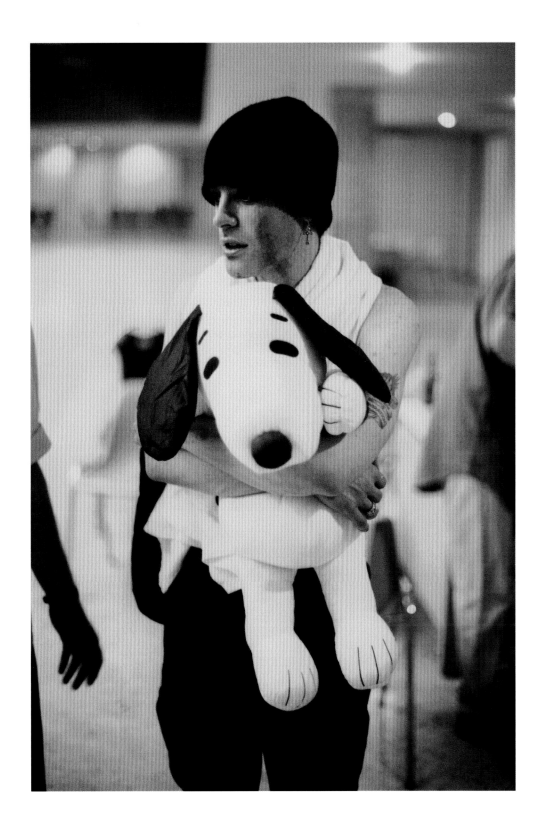

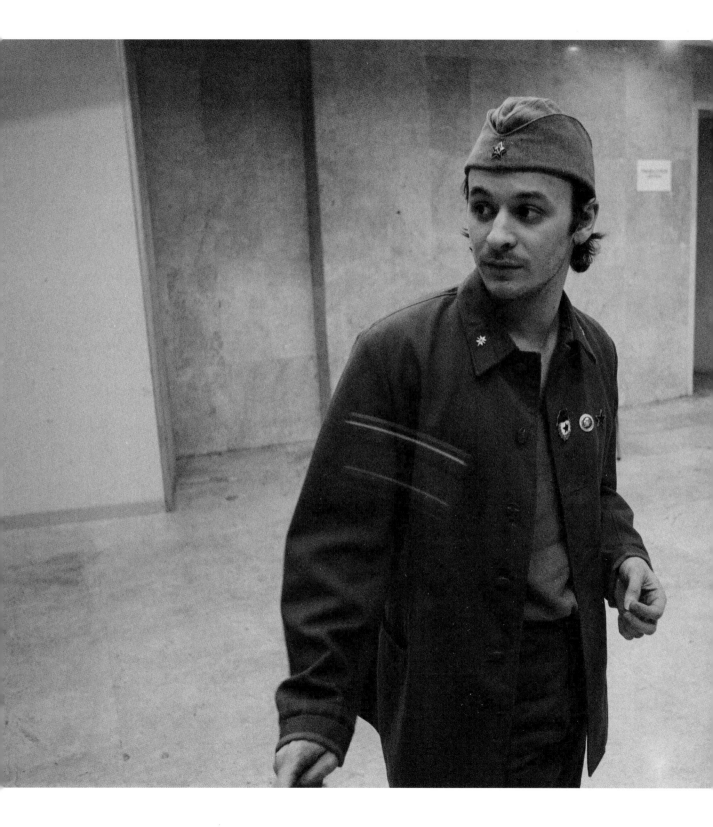

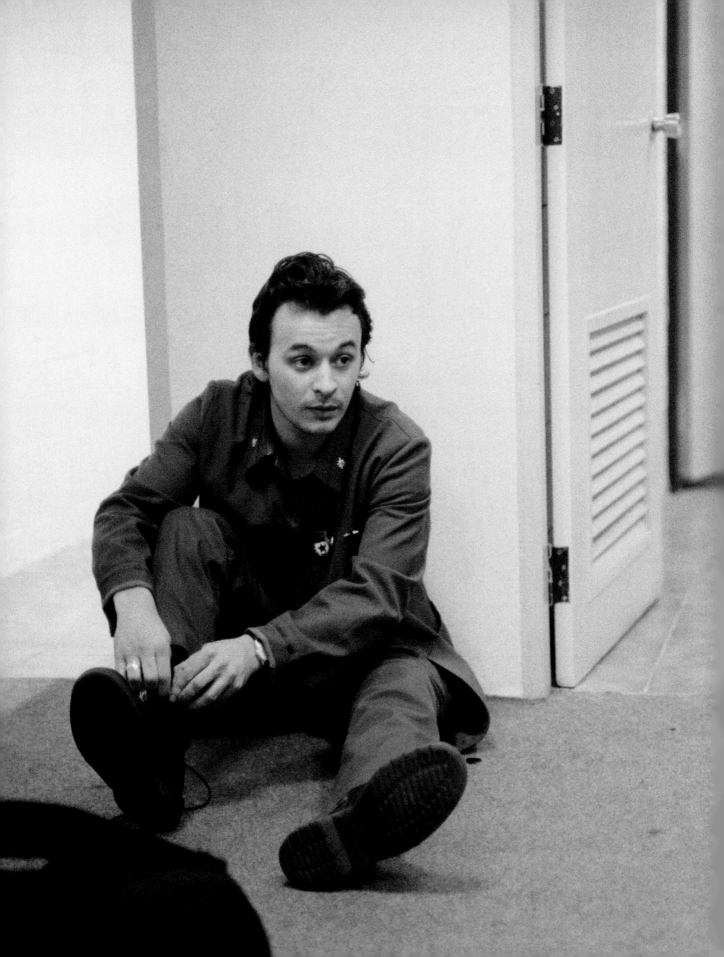

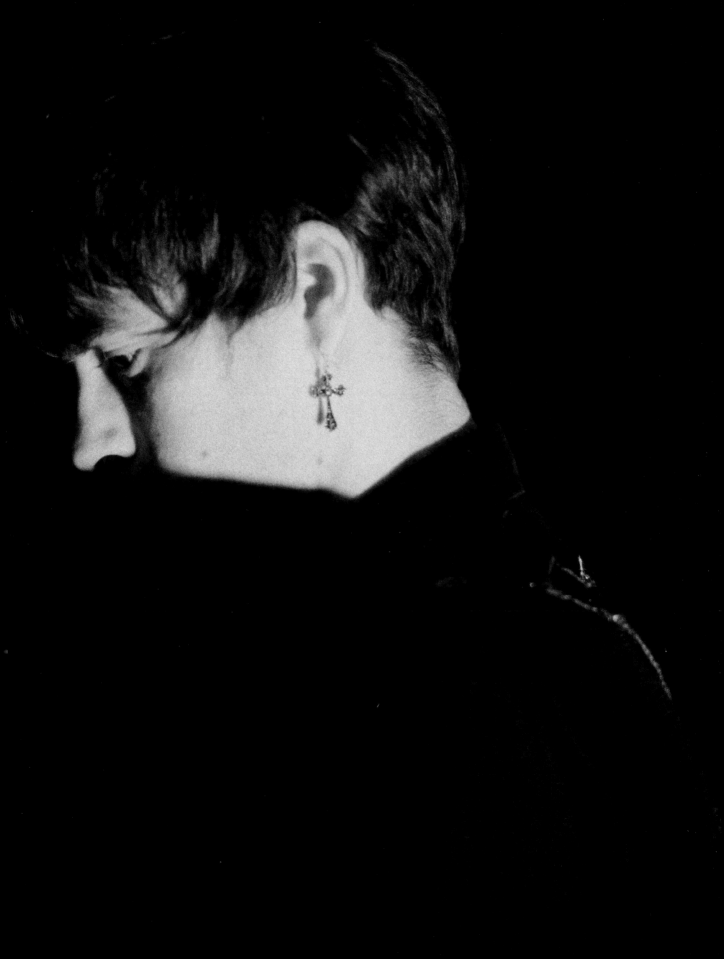

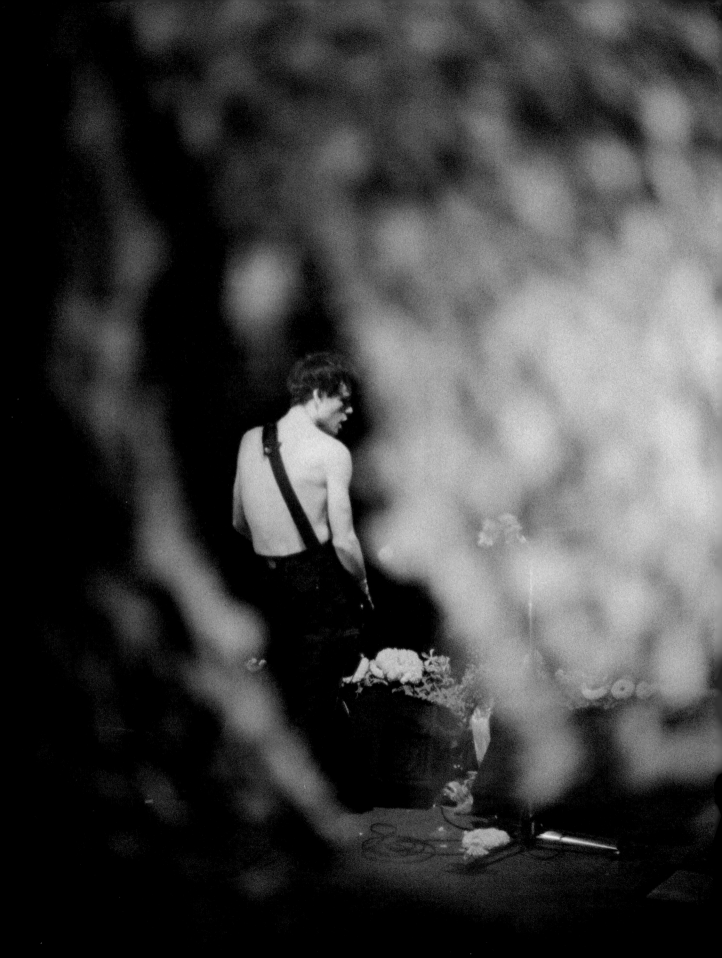

ART is the LIE that helps us understand the TRUTH

Pablo Picasso

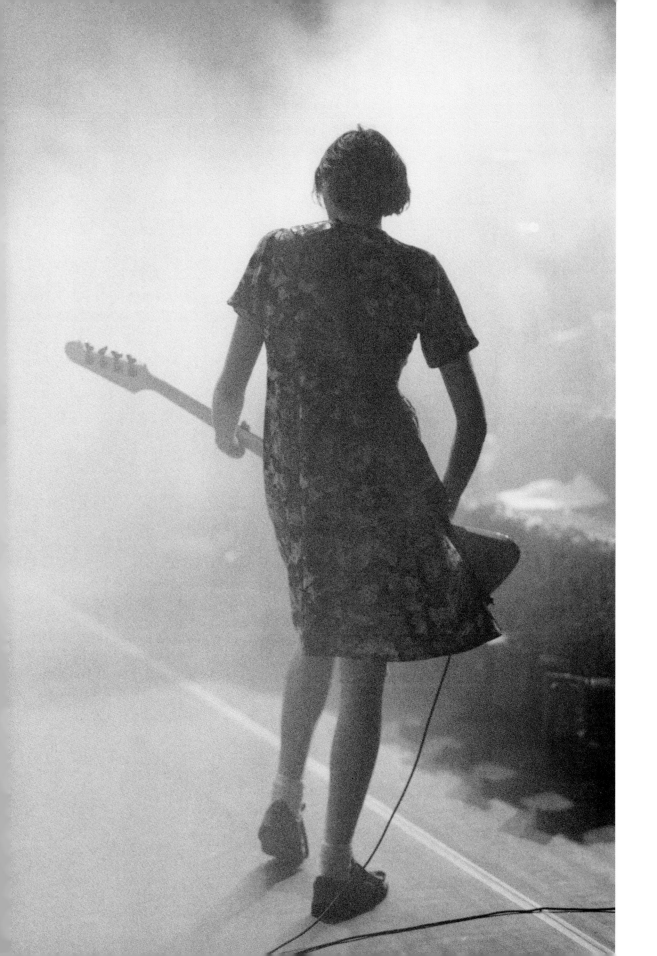

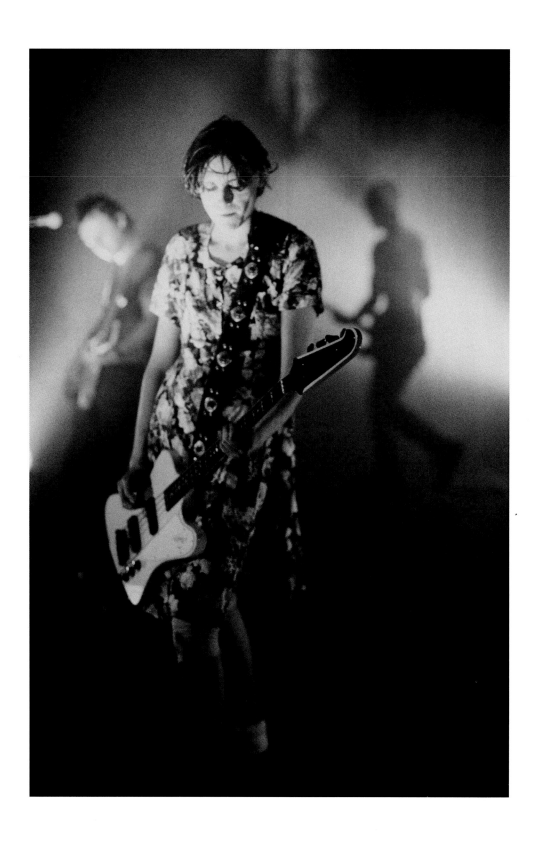

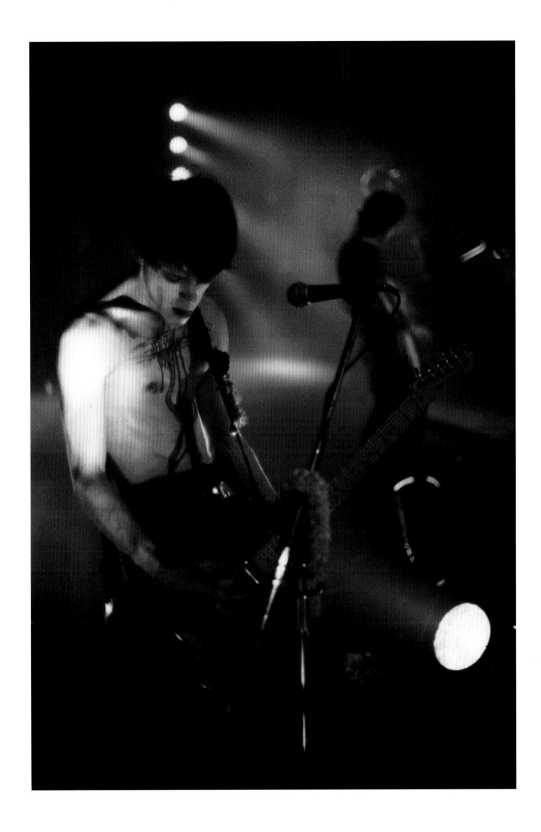

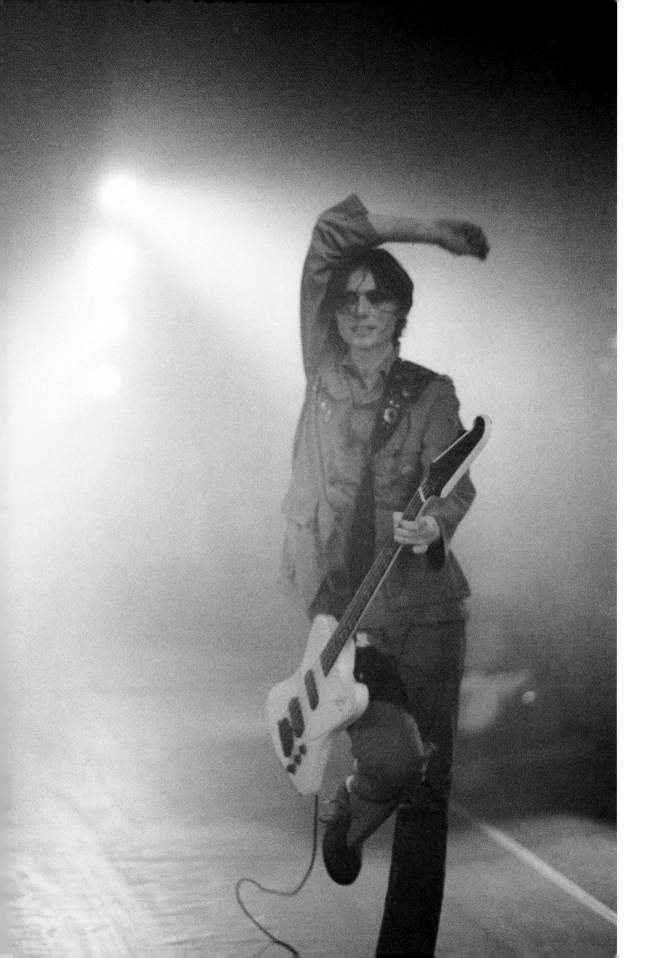

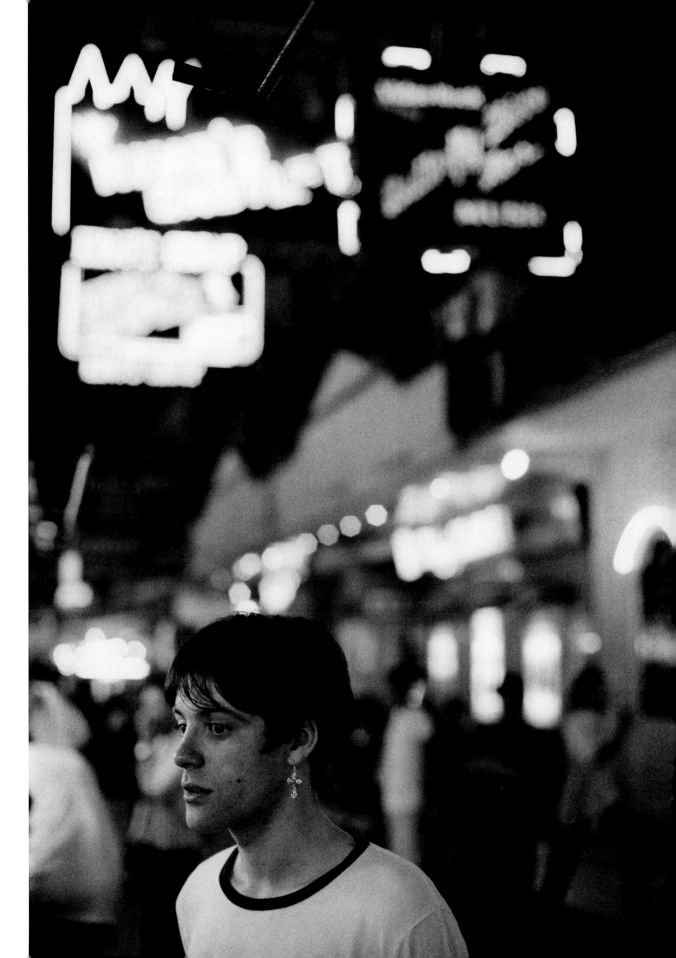

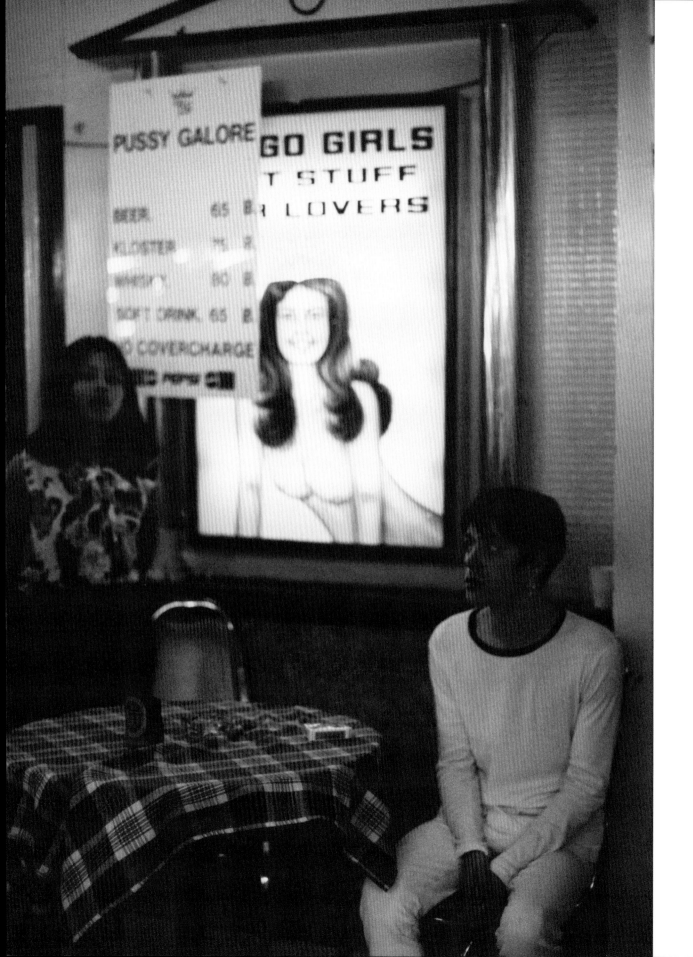

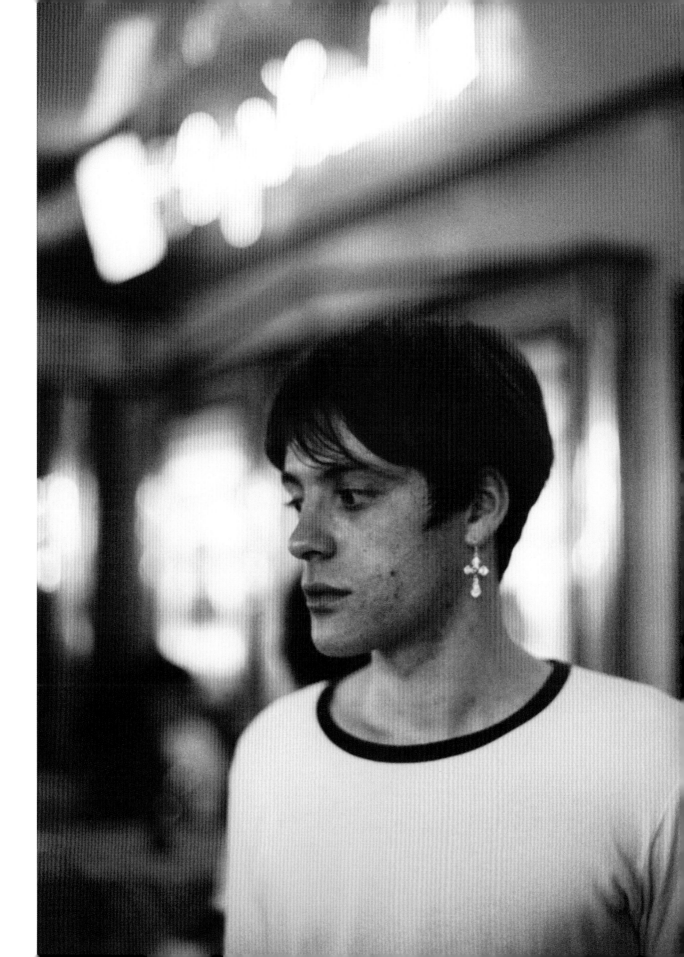

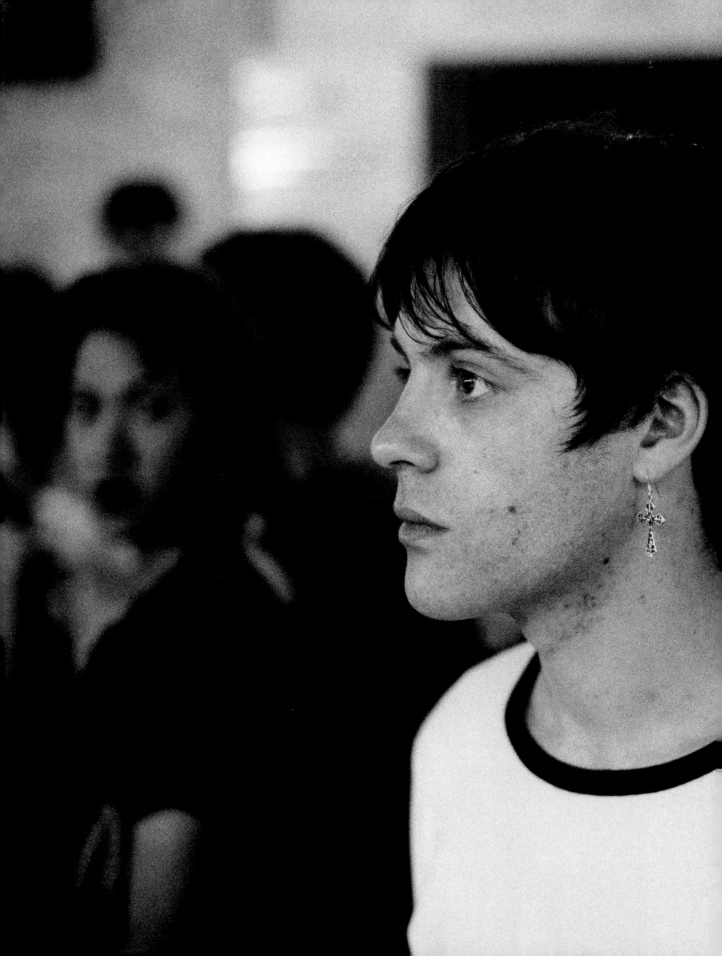

The Sleep of Reason Produces

monsters

Francisco Goya

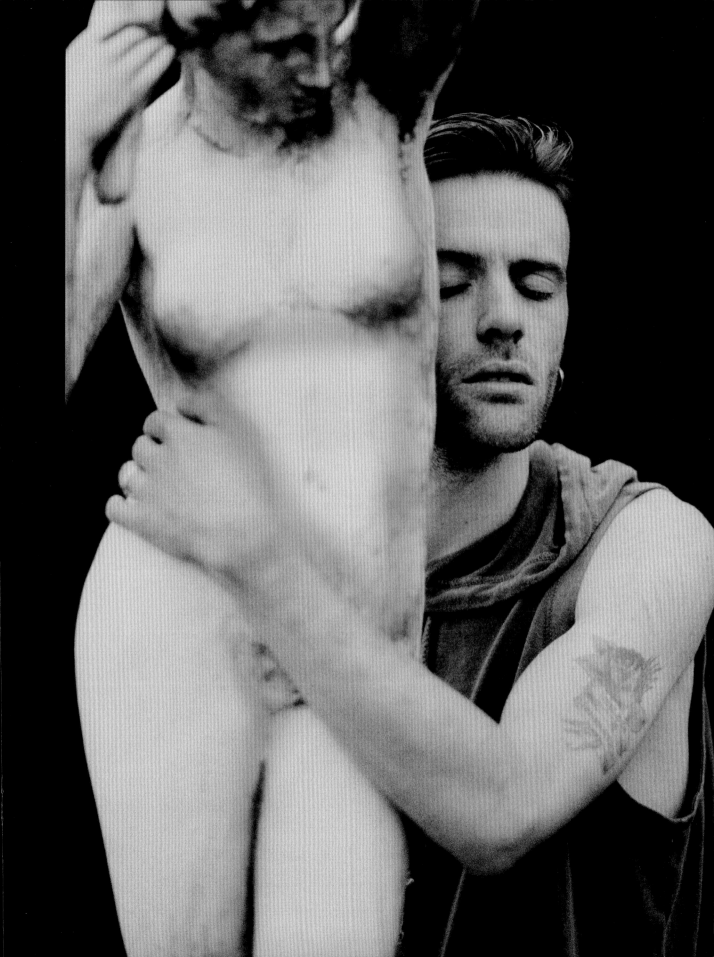

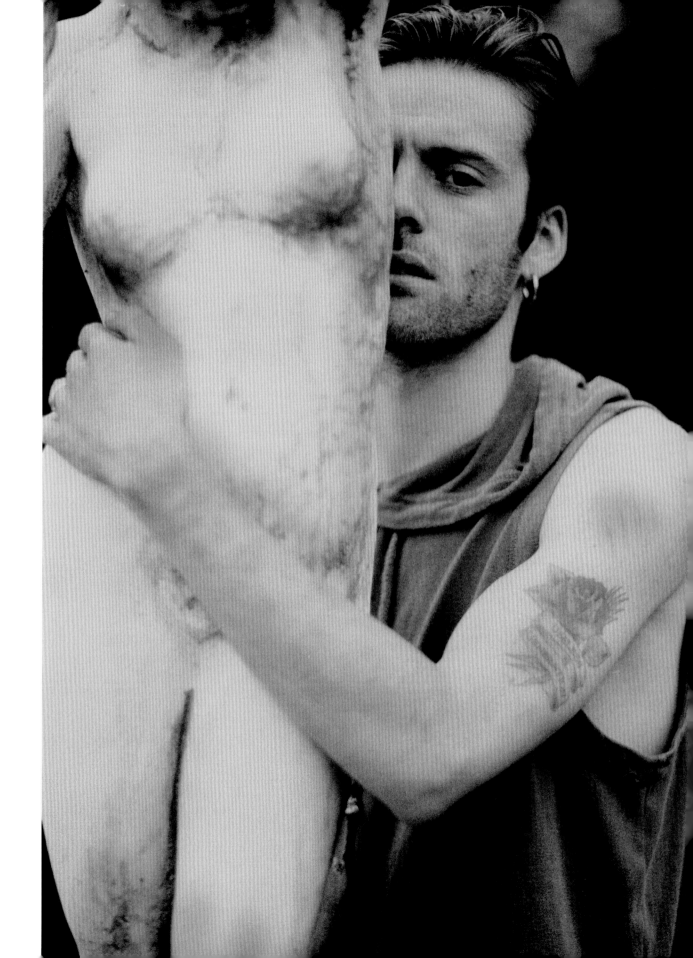

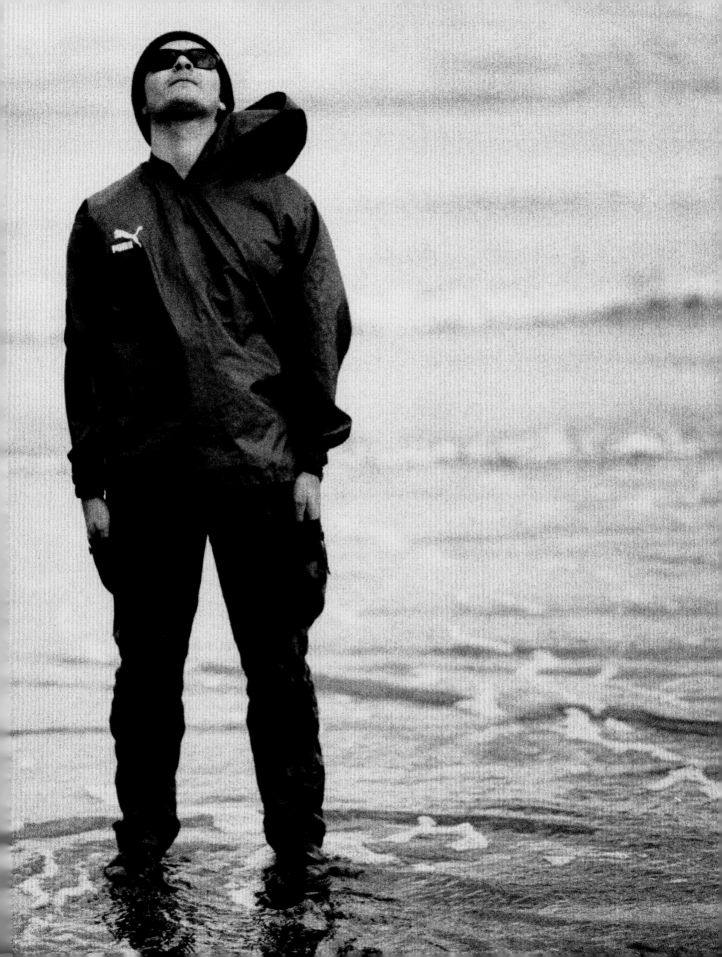

I have to

change

to stay the

SAMESAMESAMESAMESA

Willem de Kooning

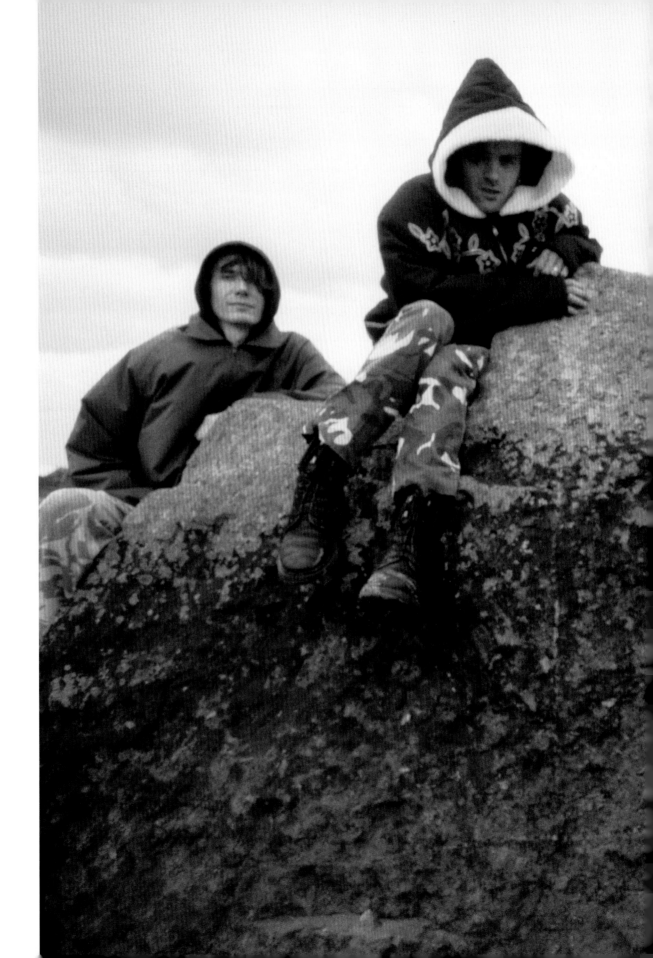

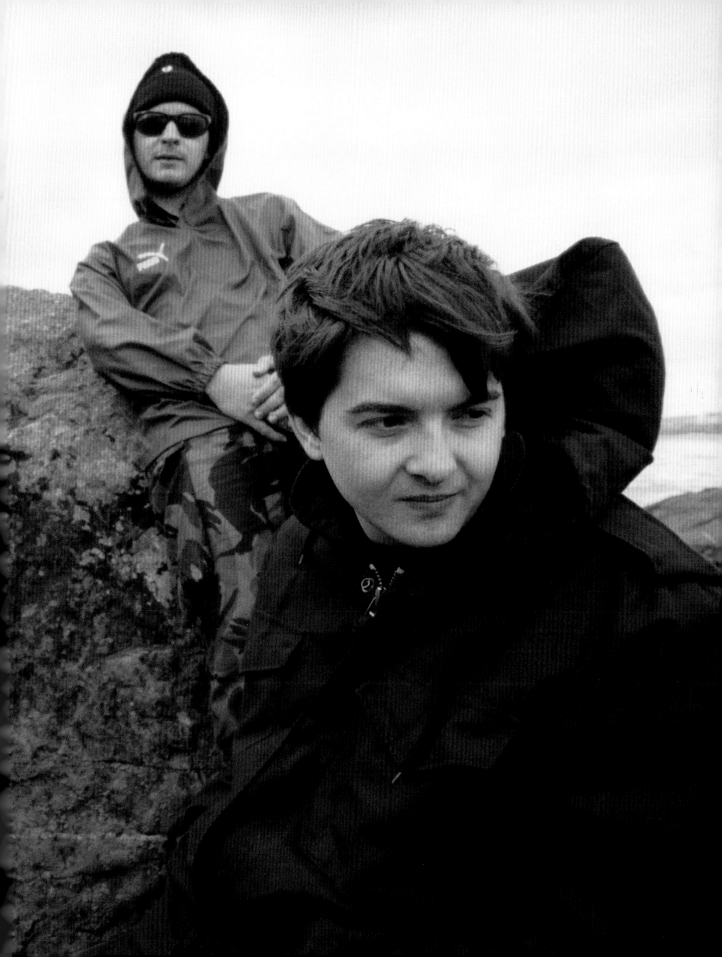

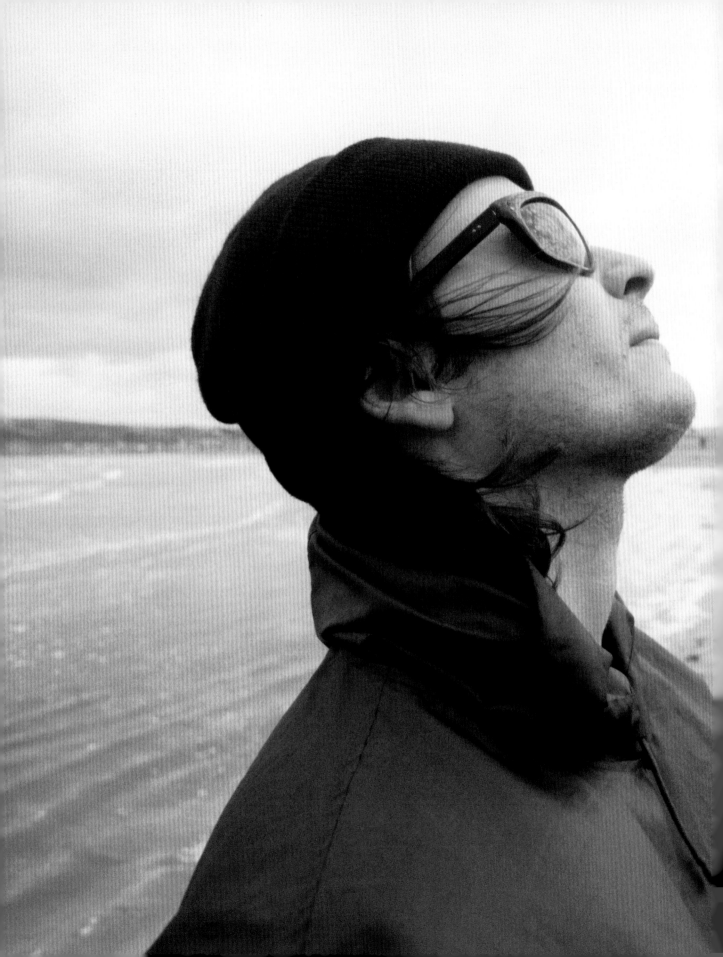

115

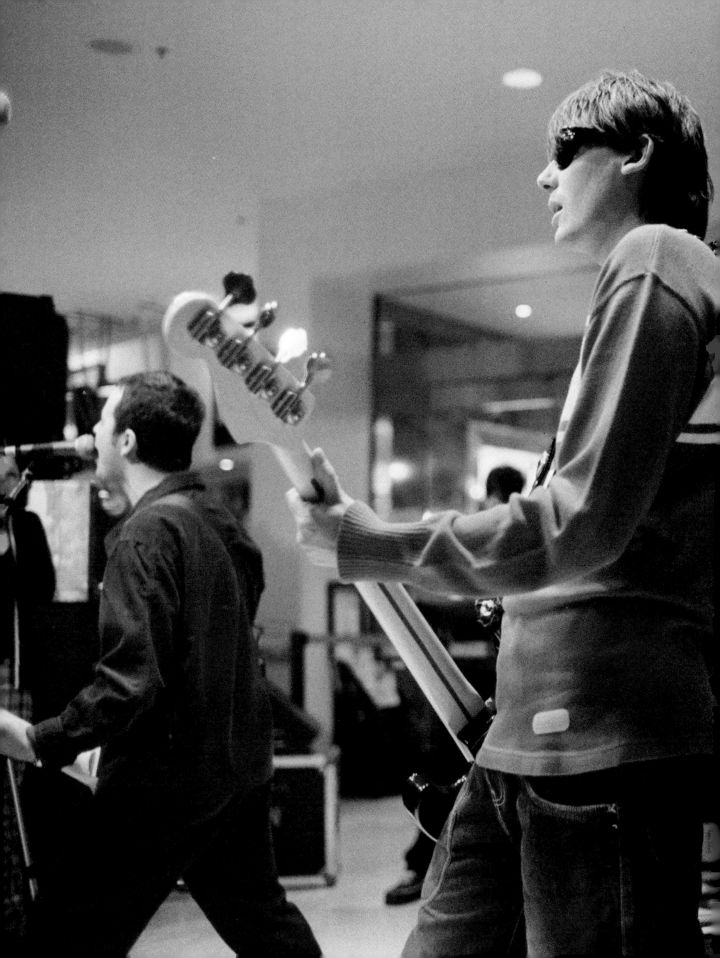

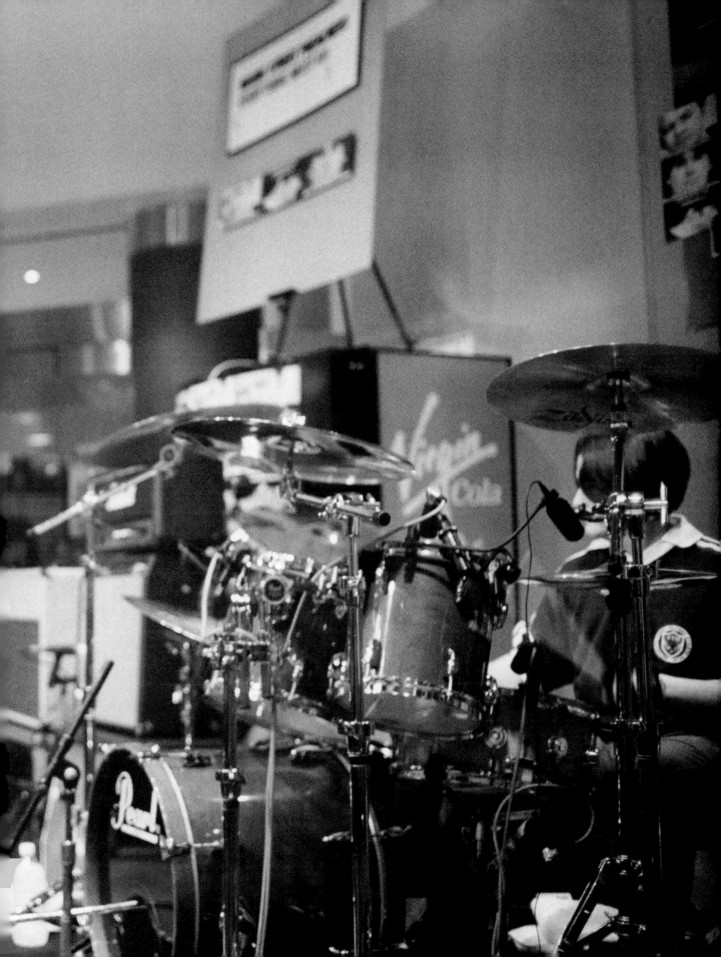

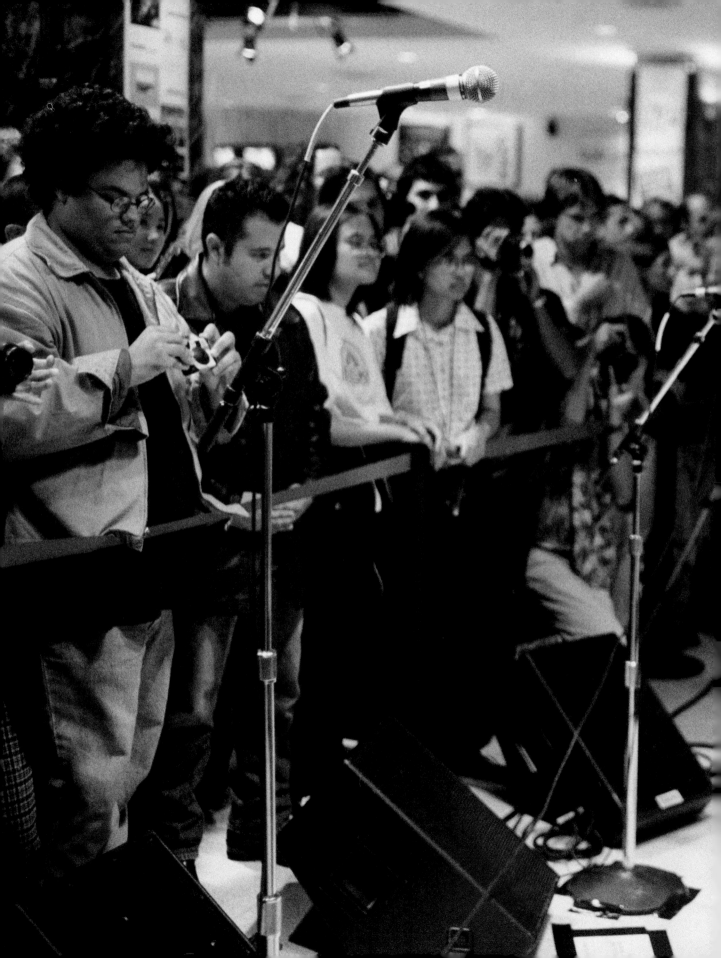

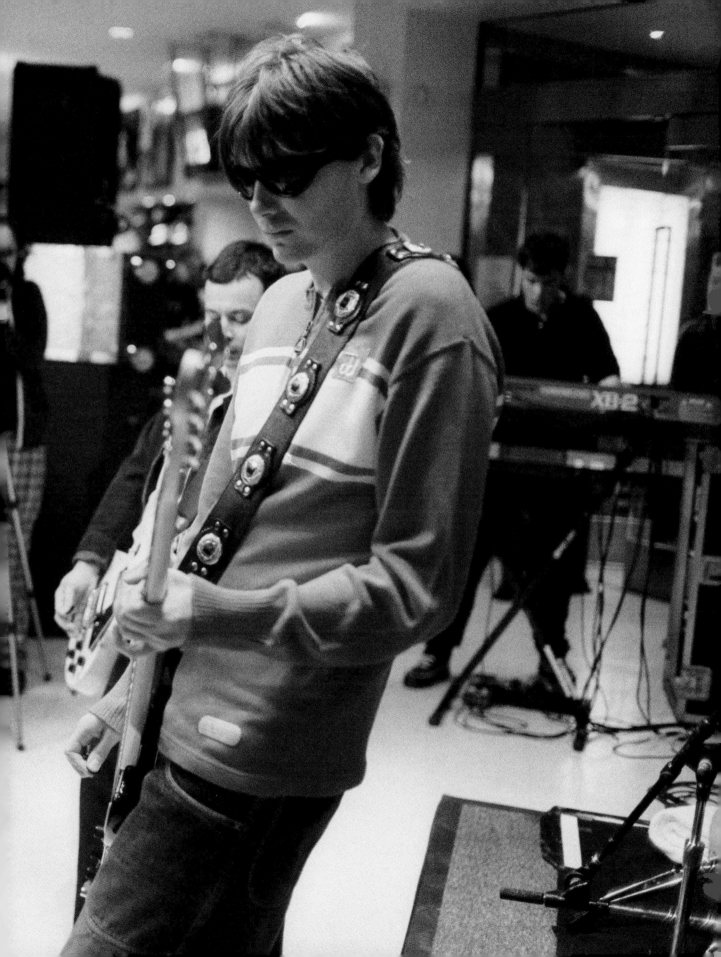

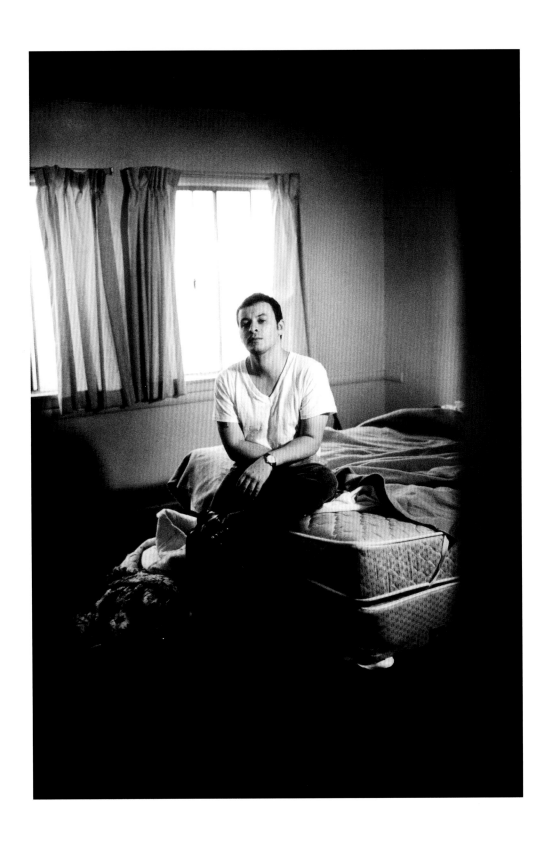

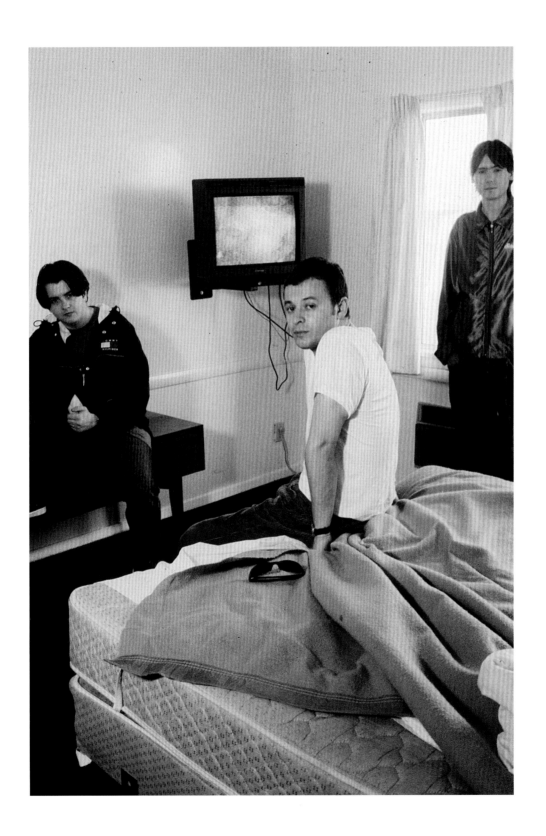

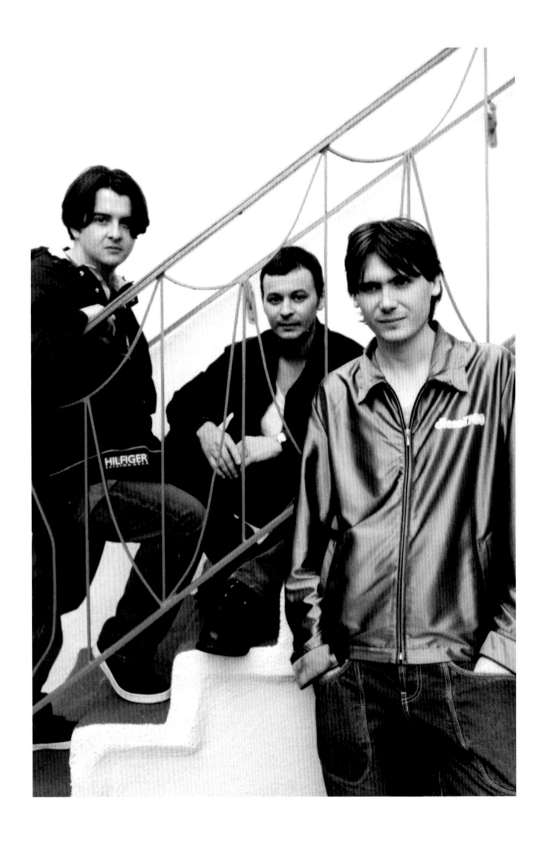

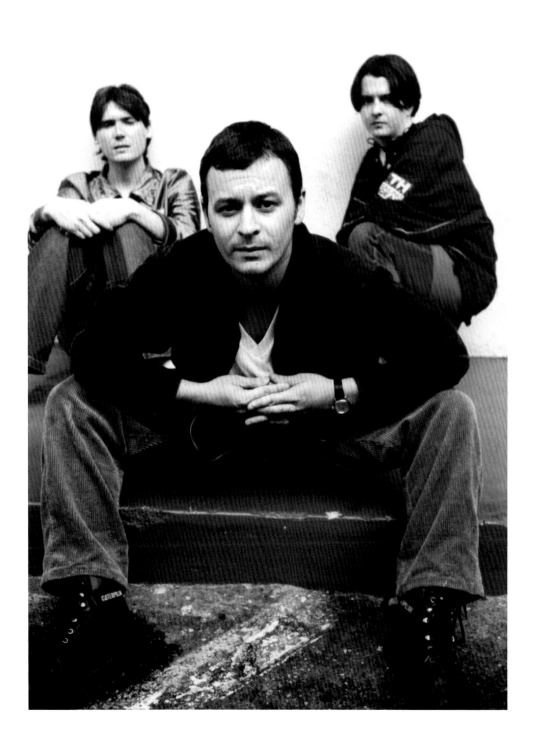

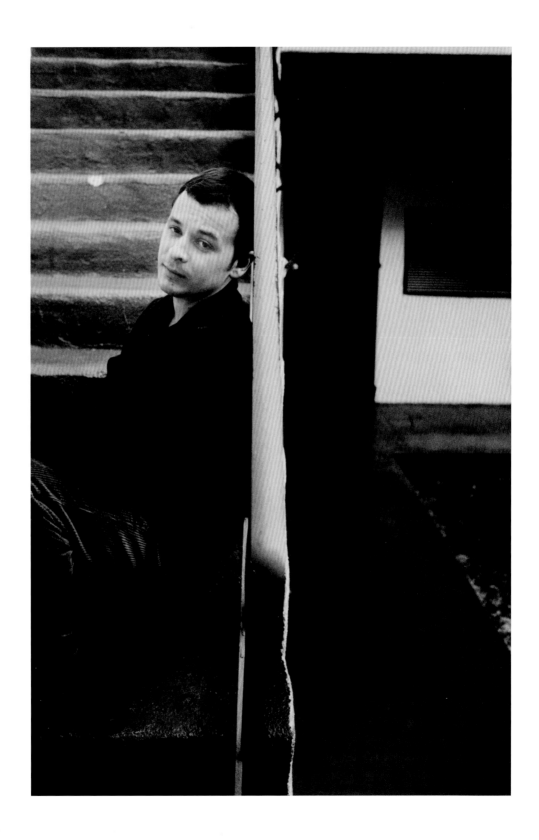

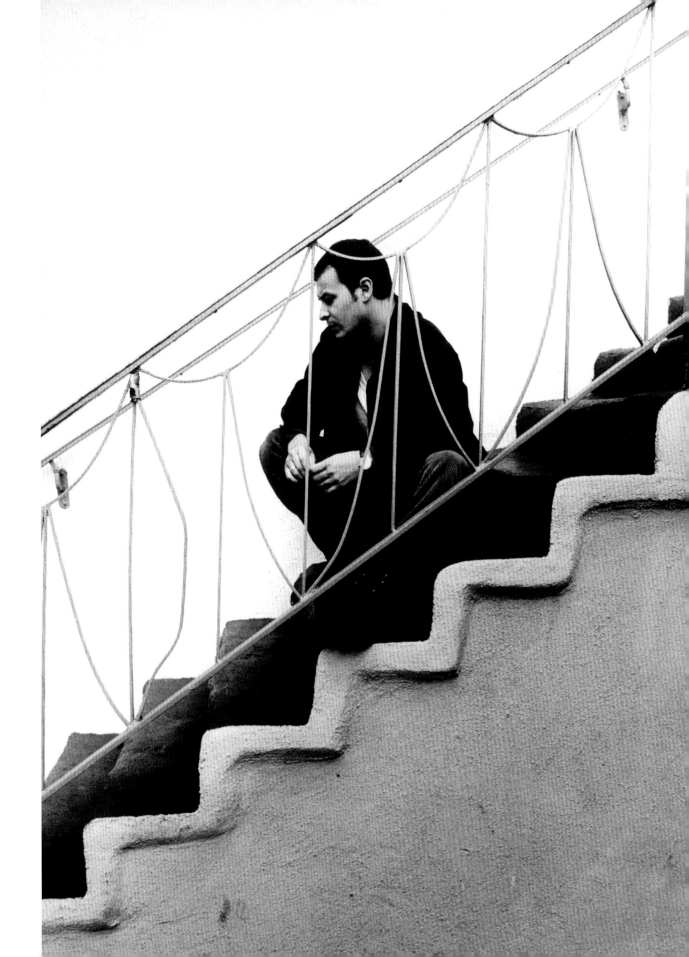

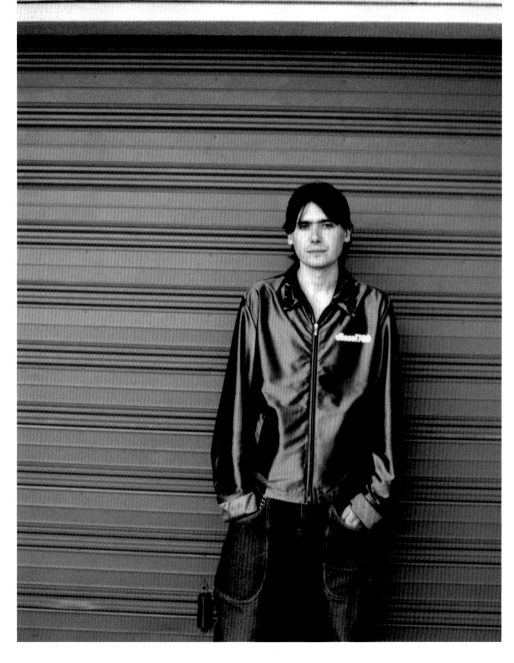

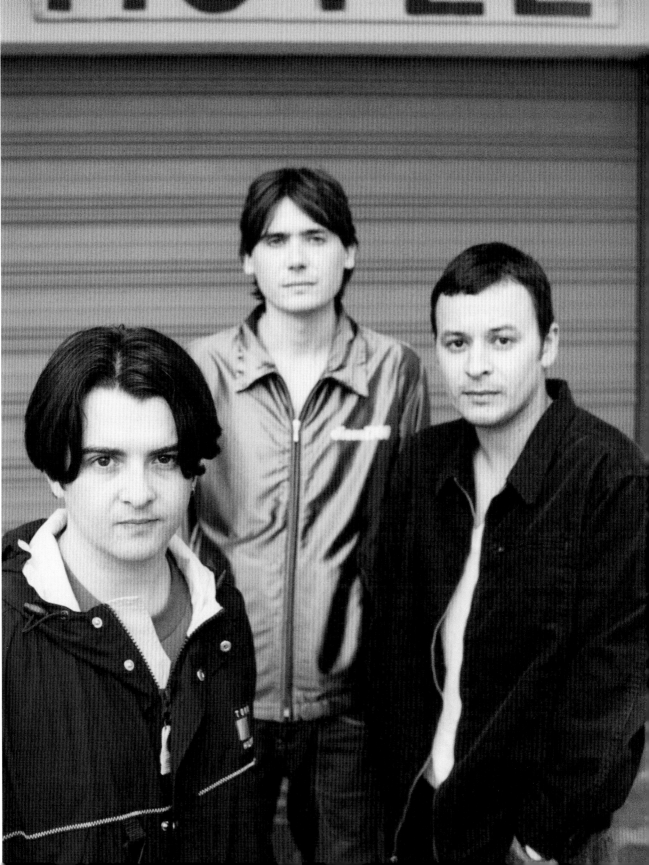

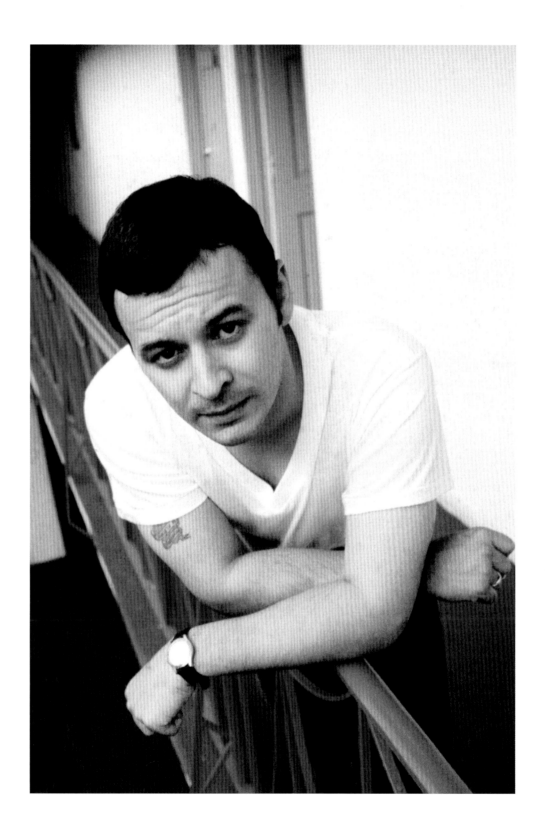

Life can only be understood backwards

but it must be lived forwards

Søren Kierkegaard

Life can only be understood backwards

but it must be lived forwards

Søren Kierkegaard

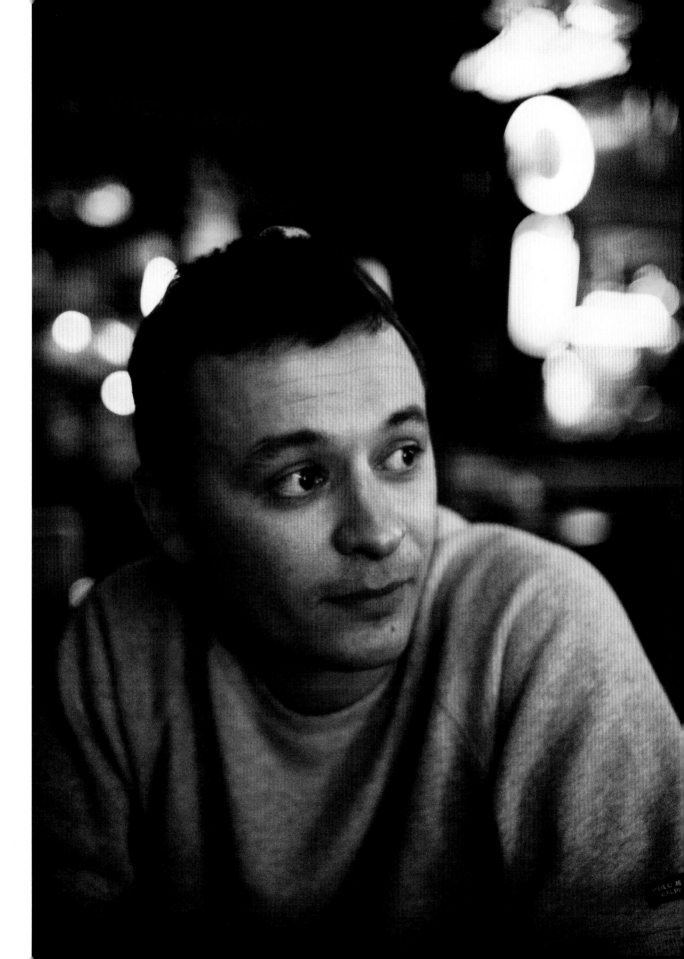

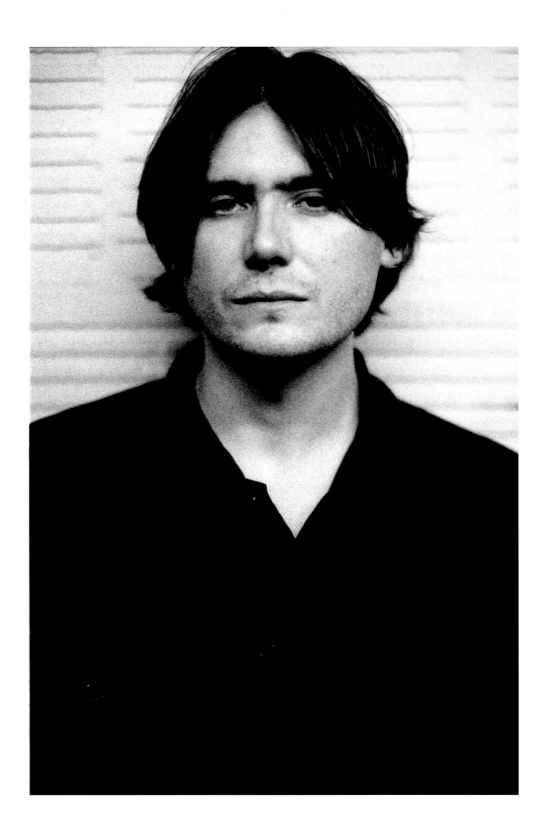

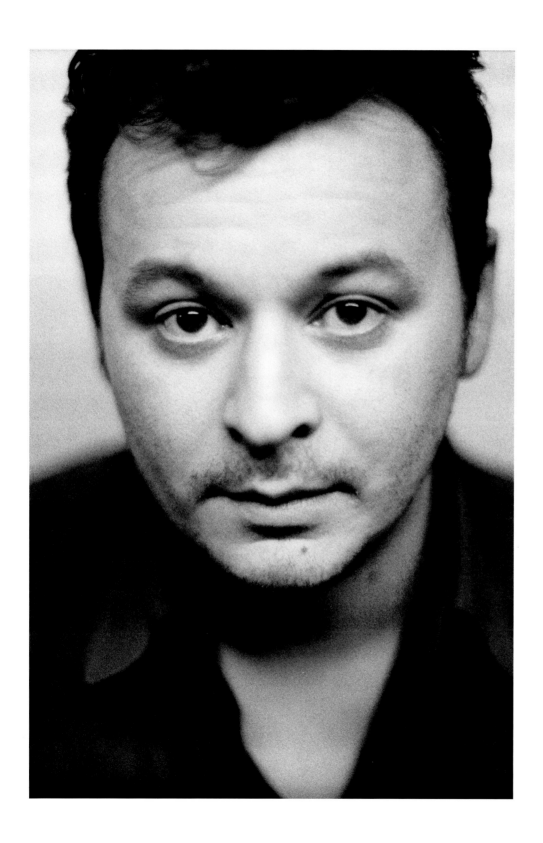

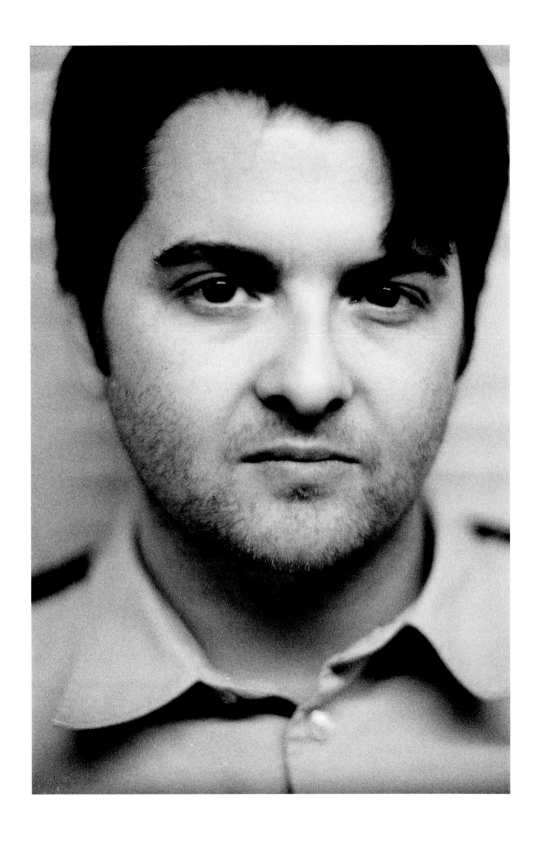

We should support whatever the enemy opposes

and oppose whatever the enemy supports

Mao Tse-tung

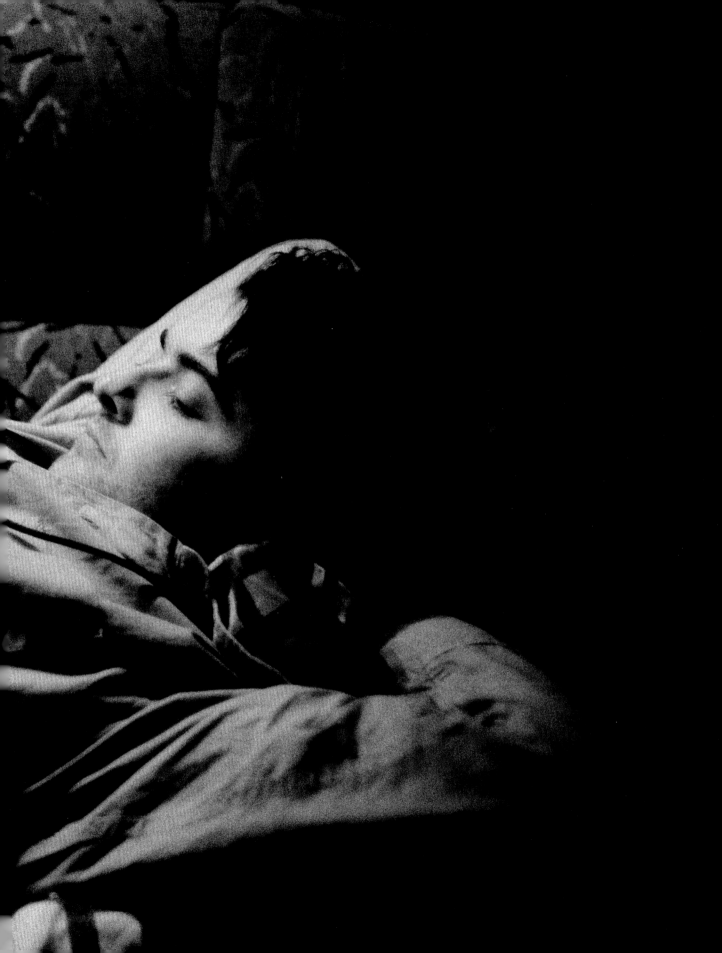

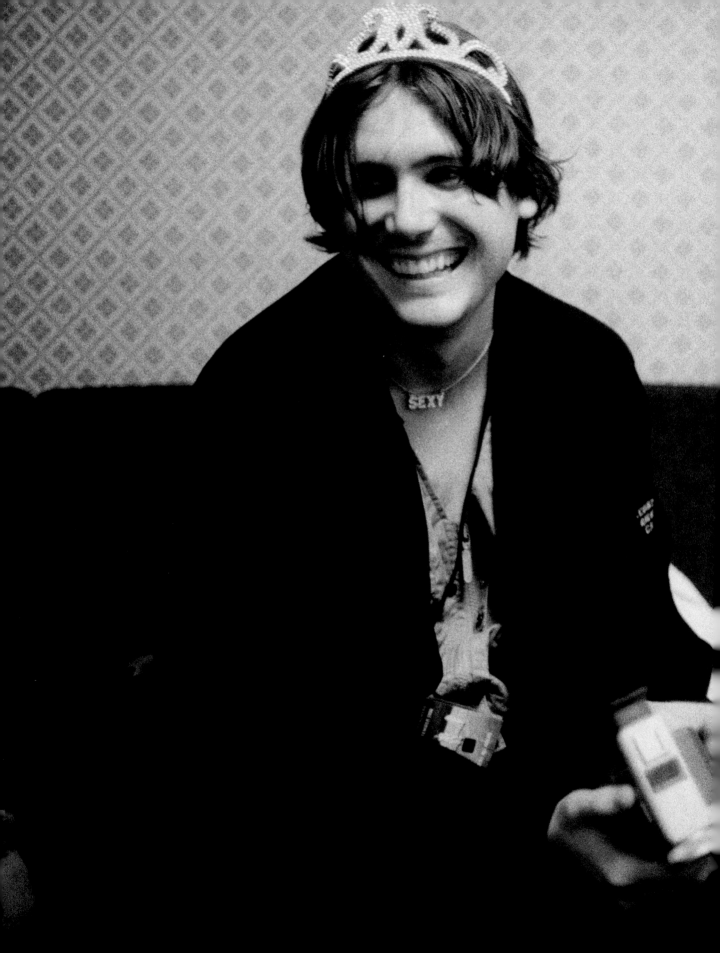

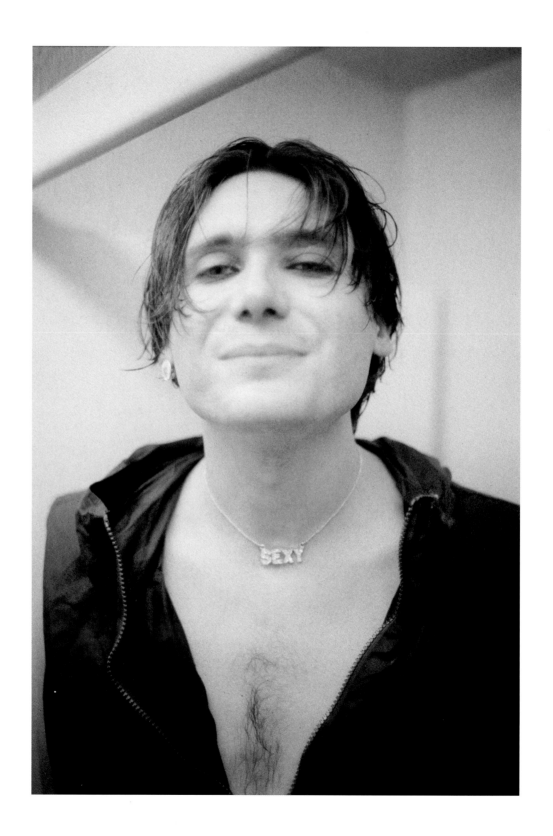

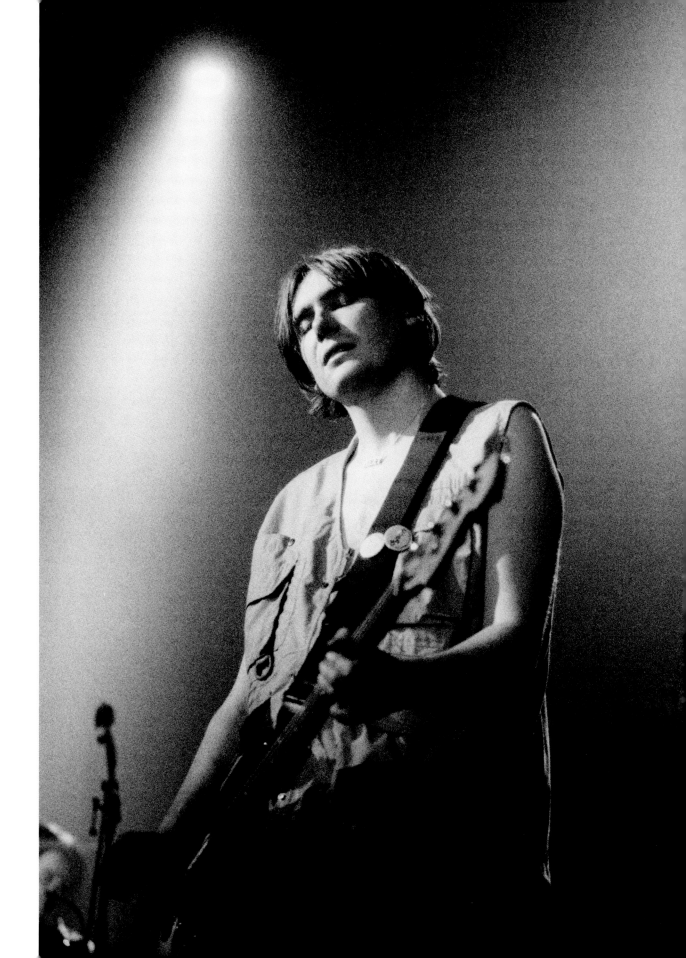

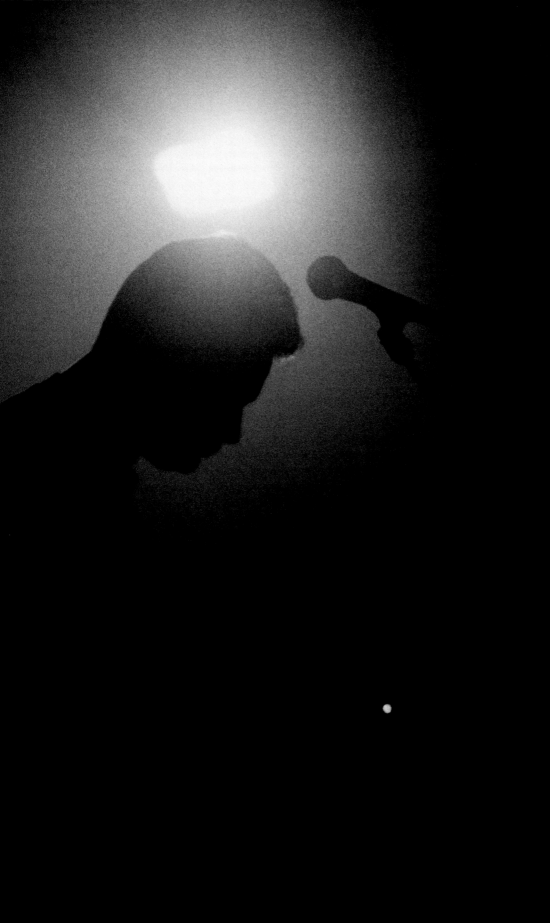

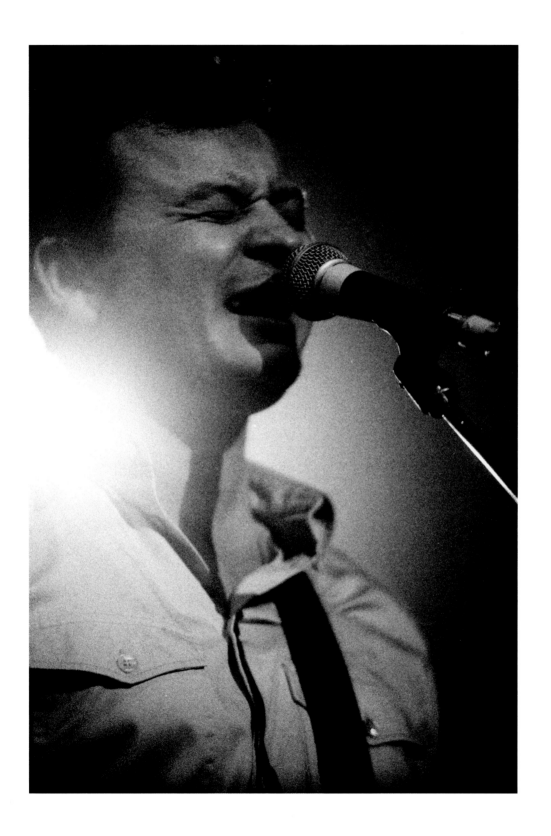

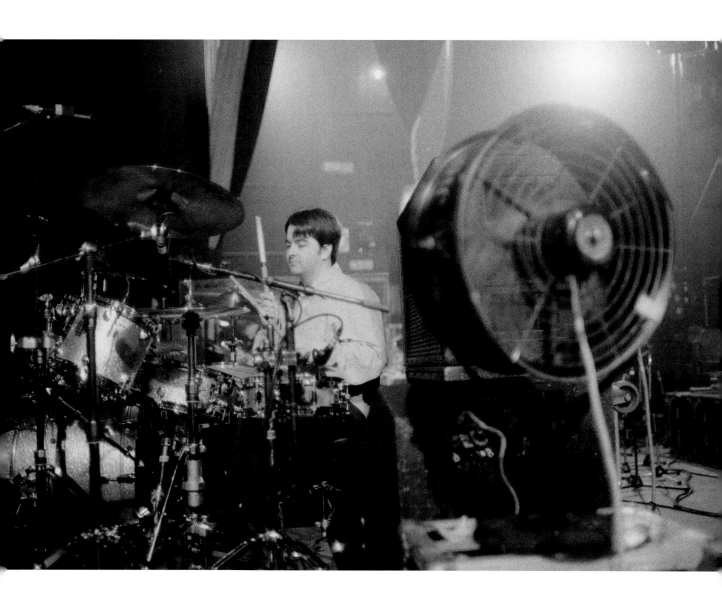

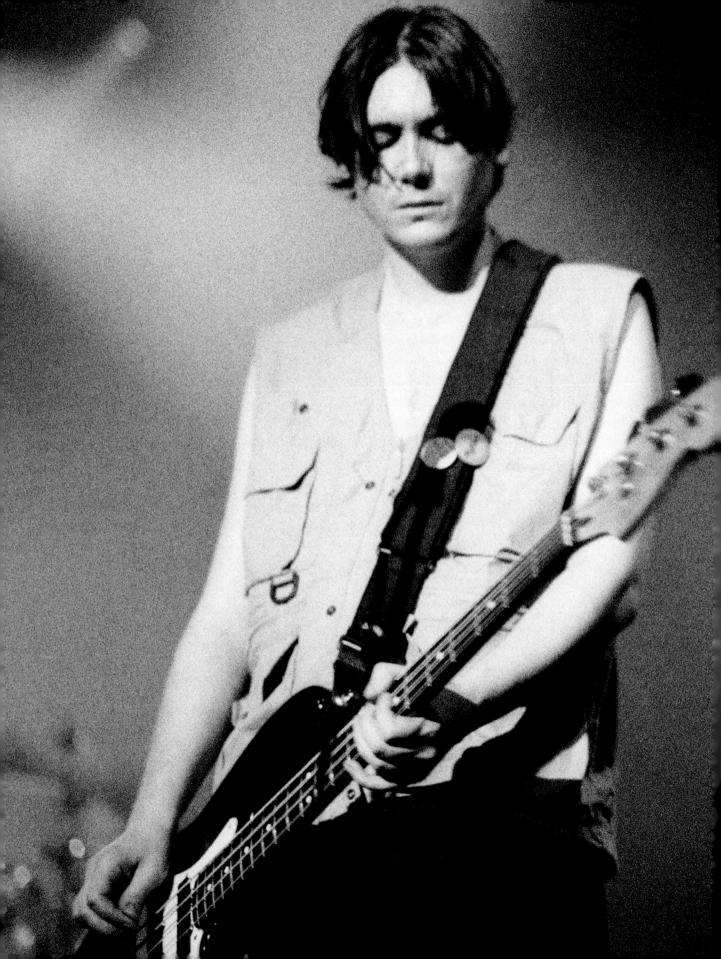

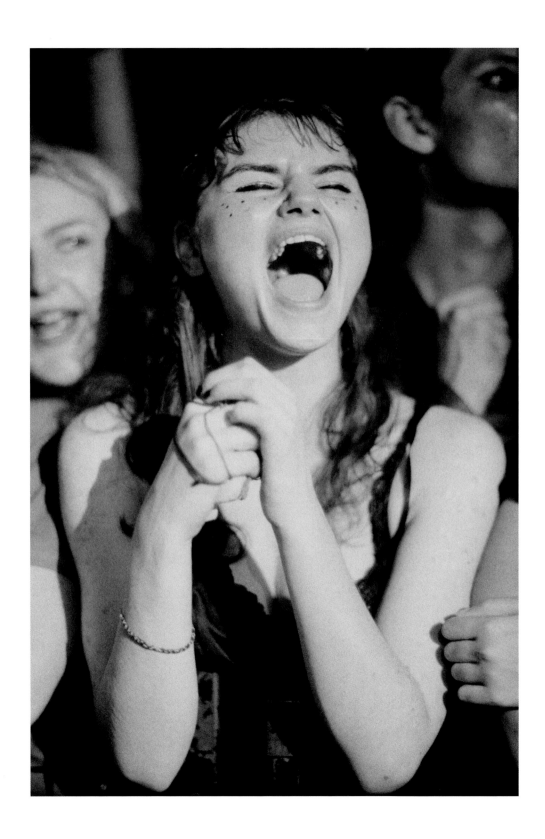

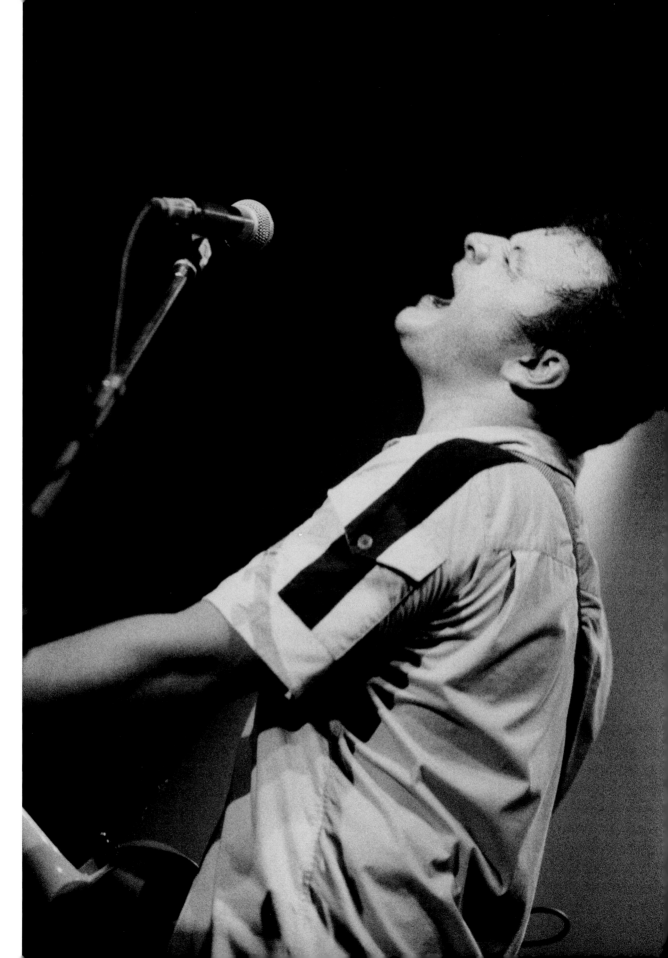

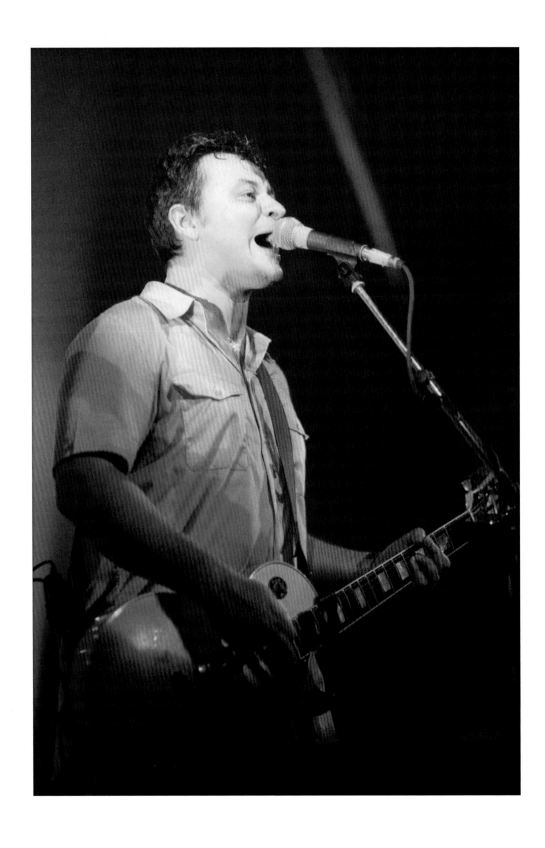

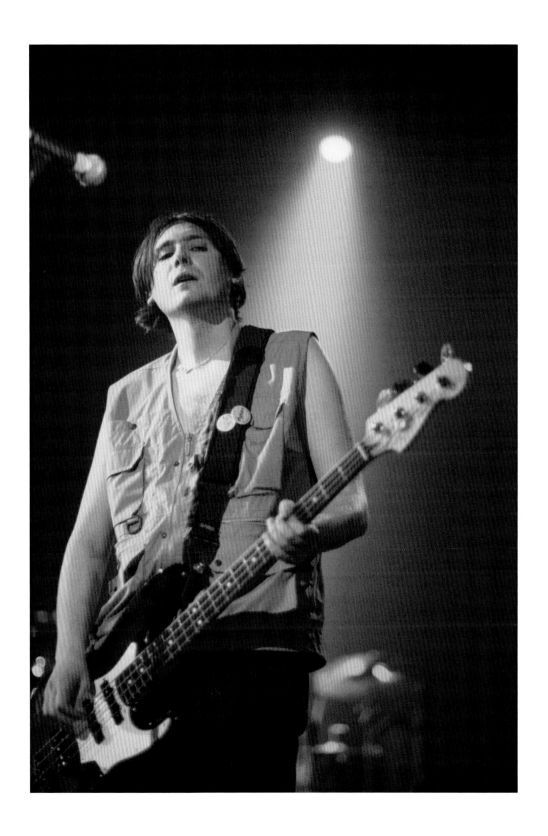

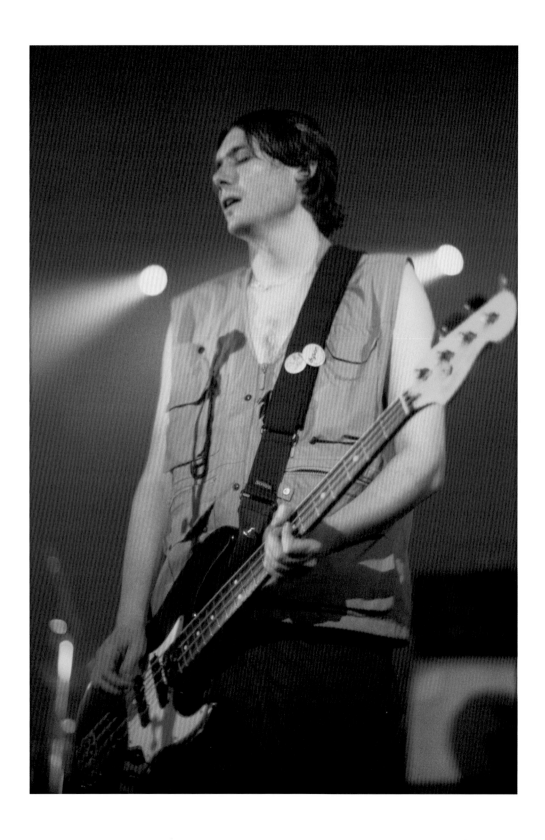

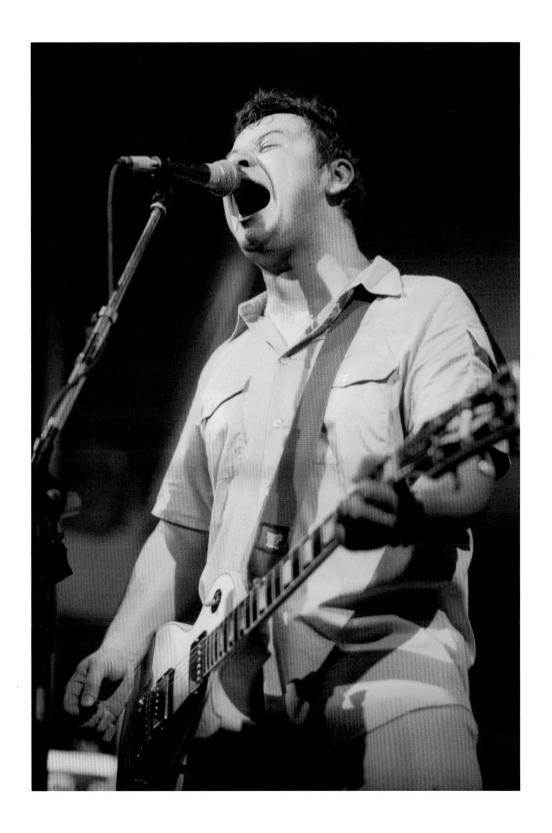

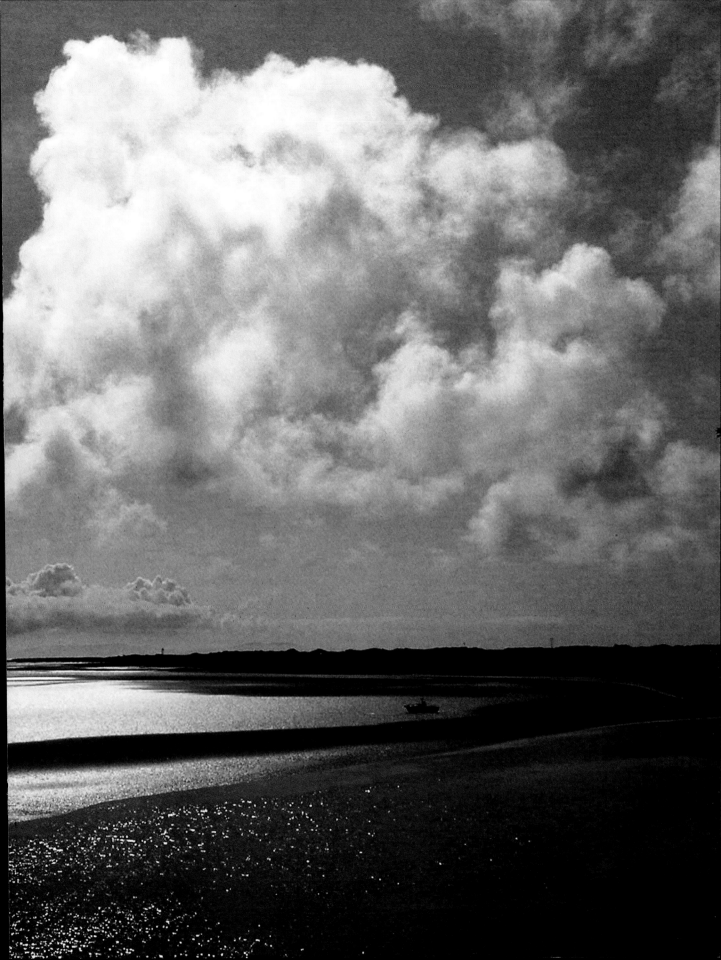

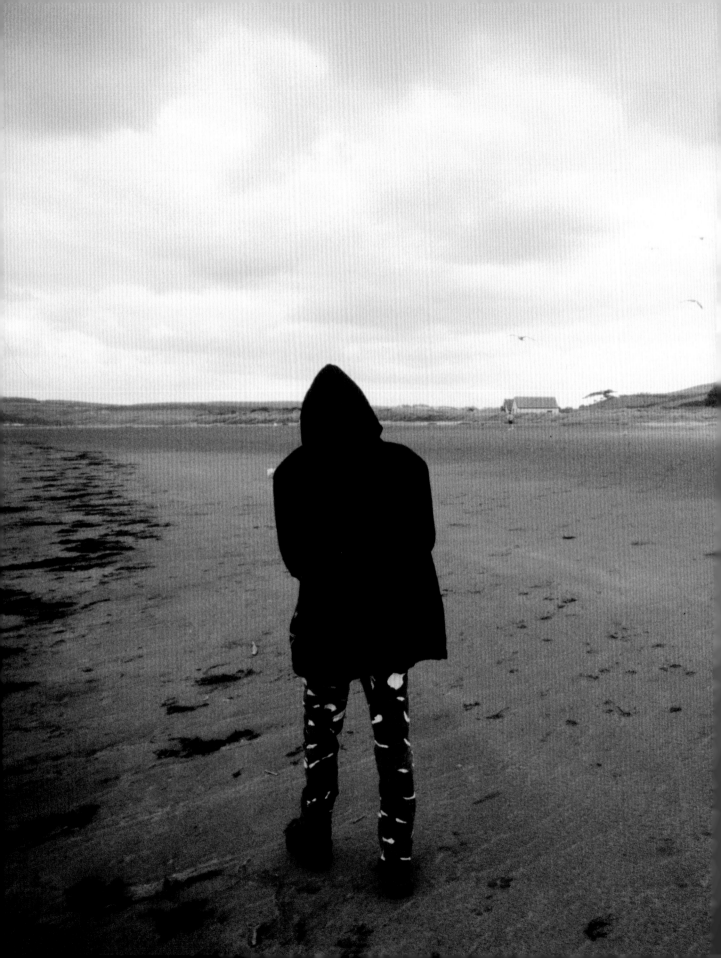

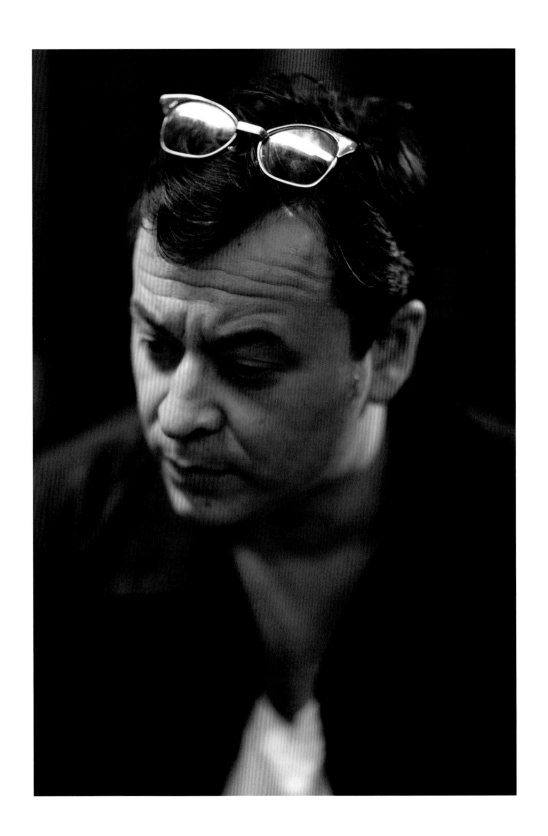

Conversation
Kevin Cummins and James Dean Bradfield

In Cardiff at the Manic Street Preachers studios, Kevin Cummins met up with James Dean Bradfield to talk about the band, their aesthetics, and the photographs in this book.

Kevin Cummins: *One of the first things I remember reading about you was when The Pixies reviewed your single in the* NME *by saying 'imagine Sham 69 with balls and brains'.*
James Dean Bradfield: We were punk snobs really. For us it was all about The Clash, the Pistols and then post-punk stuff – Skids, Magazine, Joy Division – so I think we bridled at that and also, because whilst the Pistols and Clash were undoubtedly English, Sham 69 were undoubtedly Cockney, which was a million miles away from anything we could ever have been.

KC: *Hersham boys. So Cockney . . . that's anything within the M25 is it?*
JDB: I think we always had that kind of South Walian background. We believed it was a strong position in Welsh writers, not working-class British writers: a world in working-class beginnings. Being articulate and also being quite kinetic and physical. We liked the idea of that.

KC: *And did you grow up having that idea when you were thinking of forming a band? Even before you played a note did you think you were better than a lot of the bands out there?*
JDB: I think we did. I think we thought we were definitely the best in Wales, but we were undoubtedly quite ragged and quite unformed whilst we were thinking this. So I think a lot of this arrogance was misplaced and it just came across as stupidity and naivety but, regardless of that, I think we definitely felt as if we were unique but perhaps not original.

KC: *When I started working for the* NME *with Paul Morley, we used to sit up all night after going to a gig, and make stuff up. We invented a band – The Negatives – and we made up a whole back-story about our band and sent it off to the music press. We didn't have a band, we had no intention of having a band, and yet suddenly we got to a point where we started believing it ourselves. So we decided we'd form the band. None of us could play any instruments but we just liked the idea. We were so young and arrogant that we thought we could do whatever we wanted.*

JDB: If you had the idea of a band then it would exist and it would be the best. There was a touch of that with us I think, because our ambitions were so unrealistic compared to our musical abilities. I think there was a touch of . . . if the theoretical version of the band existed then it would drag us all forward physically. So there was an element of 'if we believed in our own fantasy, it would come true' because our ideas were better than anybody else's.

KC: *When you first flirted with the idea of forming a band, did you have messages and slogans and all the anger almost before you had written a song?*
JDB: Straight away! As soon as Nicky and I formed the band. We were best mates at school and started writing songs together in early 1984 so that's how the band started, but there were already slogans and soundbites on the periphery of the songs we were writing, because every time Nicky gave me a lyric it was cut and pasted blackmail style and had slogans on the back of the lyric. When he went to university in Swansea, after we'd become a three piece, he'd send me lyrics through the post to Pontypridd, Blackwood, and every time there was a letter there would be pictures cut out and stuck on the back of the envelope and on the back of the lyrics. There would be whole letters which were just a montage of slogans. So on the periphery of the – you know – *detritus* that made up the lyrics and the sheets of our songs, it was already there. Then Nick started to make his own T-shirts and stuff . . . So a lot of that was taking inspiration from Jamie Reid, and some of The Clash's early gear as well.

KC: *Were you aware of people like Joe Orton and Ken Halliwell, and the way they would make collages and put that kind of stuff together?*
JDB: Well, I remember Nick had a picture of Joe Orton in his student flat in Swansea. It was a photo of Joe with the montage behind him. I remember that vividly.

KC: *So take me through the early process of writing a Manics song. What came first? Did you sit down together? How did you use these lyrics and cut-up quotes?*
JDB: There would be more lyrics on the page than we needed, so there would be a bit of editing, but on the back of the lyric there would always be what I now see as Nick trying to give a sort of aesthetic guidance to the song. So there would be pictures and little slogans pasted on the back or some of his own drawings, but the lyric always came as an entity on its own. I didn't have a complex, but I remember going through all the bands that we'd loved, and barely any of them had singers who didn't write the lyrics. The only one we could really come up with was Rush because Neil

Peart wrote the lyrics and obviously Roger Daltrey because Pete was the lyricist in The Who. So I was quite different in that respect. I remember thinking I'd have to put more effort into trying to interpret the lyrics, trying to make them my own because I wasn't the author. The lyrics were always the inspiration for the music, and for the first ten years of the band 99.9 per cent of the time this remained the case, and that's the way I liked it.

KC: *So when you began, which songwriters did you admire and how much thought did you put into the way they structured the songwriting process?*
JDB: I think the first thing we picked up on was Strummer and Jones because there was such clarity in the way they divided the songwriting – the lyrics by Strummer, and the music by Jones. And on 'Appetite for Destruction' by Guns N' Roses, we would see that there was a band credit and we knew that certain members of the band wrote different types of music, like Izzy Stradlin would write something a bit more Stones-esque, and Slash would come from a very much heavier, classic-rock background.

But I think the main thing we picked up on was that there had to be a focal point for the lyrics in the band, whether it be John Lydon who you knew wrote the lyrics, Axl Rose, Ian McCulloch, Jim Kerr in the early Simple Minds, or Joe Strummer. We realised there had to be a clarity and purpose of vision, because I think even back then we thought that all good music came from great lyrics.

The first lyricist I ever worked with was Nick. I was writing the music for his lyrics. But I was always really just gagging to get lyrics off him, and when Richey joined and they became a lyrical team together, that became even more forceful and it had an identity of its own. I think we really sought out great identifiable lyricists first and foremost at the start.

KC: *If you'd been from London I don't think you would have existed in the same way because there was a certain naivety about a lot of the things you did early on. It wouldn't have necessarily been cool then to look at Guns N' Roses as well as the Bunnymen, PiL or the Sex Pistols.*
JDB: I think there's two ways you can look at that. You can see that we had a clarity of vision because we were outside of the London bubble, so we realised that Guns N' Roses weren't just a hair-metal band, they were actually a rock and roll band. You know there's that great quote from Mark E. Smith when he said, 'There's a lot of rock music around at the moment, but the rock is nothing without a roll.' That's why we realised Guns N' Roses were amazing because they were rock and roll. They weren't just a

rock band, you could see they were influenced by Alice Cooper, The Rolling Stones and a bit of Gram Parsons – believe it or not Slash was a massive Gram Parsons fan . . .

So living outside London we could see that, whereas the only people who were really writing about Guns N' Roses at that point in London were *Metal Hammer* and *Kerrang!* and it was looked down upon. What happened fifteen years later was lots of kids that were in the indie-rock world were starting to wear Guns N' Roses T-shirts, because they realised that they were a cool, strutting rock and roll band rather than a metal band. I don't see that as naivety. We just actually didn't have the kind of snobbery that existed in London. Yes we were naive because we were prepared to wear our hearts on our sleeves. If something excited us and communicated a glamorous vision to the outside world we just picked up on it and ran with it, so there was a bit of naivety there as well. It's really strange, we were a bunch of elitist indie snobs on the sly, but also we were just kind of magpies – eclectic naive valley boys . . .

KC: *Were you all into the same iconography, or did you all contribute different things to the Manics' aesthetic?*
JDB: I think at the start Richey was very much an Echo and the Bunnymen fan. He was also fanatic about Einstürzende Neubauten – I remember he had the album *Collapse*, which he played all the time. He loved *Fire Dances* by Killing Joke, and he was a massive Fall fan – *Perverted by Language*.

Nick, on the other hand, came from a metal background until he got to fifteen and became a massive, massive Smiths fan. It's really hard to overestimate the effect that Morrissey had on Nick. I remember after their first time on *Top of the Pops*, Nick came in and I think he'd probably been trying to put some daffodils in his back pocket . . .

Nick was a massive McCarthy fan as well. I think Nick always kind of wanted the music to be infused by some kind of political purpose. Obviously with The Smiths you had *The Queen Is Dead*.

Sean was into colder, more technological music. I remember he was playing *Autobahn* by Kraftwerk from when he was about fourteen years old. He was into Blancmange and The Residents as well, and he had a keyboard at home and he took it apart one day to try and see if he could get different sounds. I came home and he had wires all over the place, and I said, 'What you doing?' and he went, 'I was seeing if I can get the sound they get on

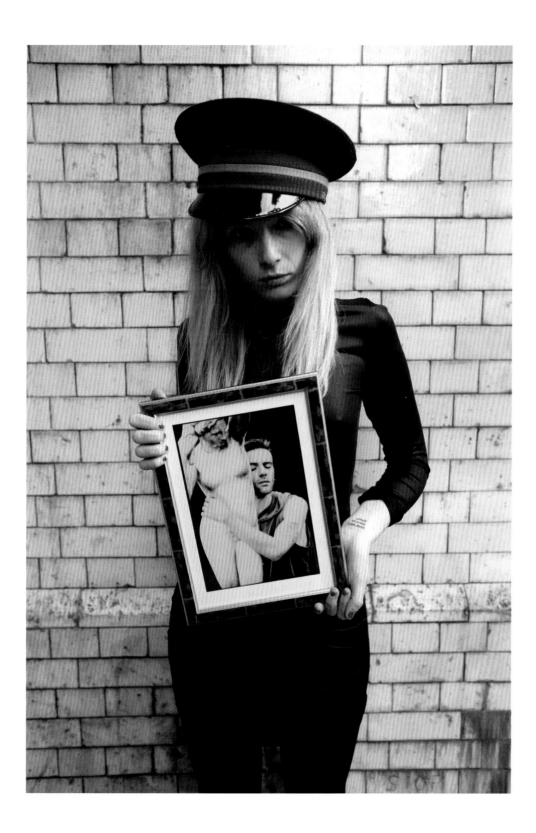

"The Model" and "Autobahn" off this little crappy keyboard,' and of course he never put it back together again.

I was a big fan of Motown and Sinatra, and then indie just fucking went mental for me. I was into The Bodines. I was into The June Brides. Big Flame from Manchester are one of my favourite bands of all time. I had a little bit of a fan correspondence with them. I was trying to get to their last ever gig, which I think was at the Boardwalk, and they used to send me letters back. I used to fucking love Big Flame records: 'Why Popstars Can't Dance' was just so brilliant . . . and I was into That Petrol Emotion, too. And then the one thing that unified us all was The Clash, because Tony Wilson did a *So It Goes* TV documentary for punk's tenth anniversary and it had The Clash doing 'Garageland' and 'What's My Name' at Manchester Free Trade Hall and Magazine were on there.

KC: *The Clash gig was at the Elizabethan Hall at Belle Vue.*
JDB: Oh was it? I knew you'd put me right on that one . . . It was weird because we all congregated around that one TV show, we all videotaped it and I remember, what song did Joy Division do on there? 'To the centre of the city in the night . . .'

KC: '*Shadowplay'. There were only two tracks from Joy Division on the show.*
JDB: I remember calling Nick that night and saying, 'Did you see that? It was amazing,' and I remember him coming back and telling me about Joe Strummer's hand movements and the moment when he falls against the drum riser and everything. There was another guy in the band at that point as well, a guy called Flicker who was the original bass player, and I remember calling him that night and just going, 'That's the most amazing thing I've ever seen.' That was our road to Damascus moment, watching that documentary. And then when Richey came along after that we all had our unifying moment when we said, 'Oh my god, did you see that six months ago? It was amazing.' That's what we wanted to be.

So we all had very different influences, but that became our absolute bullet point – a rallying call.

KC: *Obviously for me it's interesting that it comes from Manchester . . .*
JDB: I think at one point Scotland kind of ruled the post-punk world, but just before that it was Manchester. I was a massive Magazine fan before I saw the *So It Goes* programme, and it seems so much footage was from Manchester. I can't overestimate the influence that ten-year anniversary

KC: *And when did you first realise that Richey had the rock-star look?*

JDB: We were all meeting up in Blackwood to go to the Red Lion because it had a brilliant fruit machine and we'd save up to put money in there. We'd all stand around it in our white jeans and just have a few halves of pop, trying to look cool around the fruit machine, and at this point Richey hadn't caught up with our look yet – we were just deciding to get him in the band. So we were meeting up in Blackwood to go up the Red Lion and we were all dressed in our gear, and suddenly Richey comes down the hill past Blackwood Library in white jeans, a kind of purplish jacket with a rose in it, and his Ian McCulloch haircut had been subdued into something which was a bit more Hanoi Rocks, and he had some necklaces on, and eyeliner and Cuban heels, and it was just, 'Who the fuck is that? I know it's Richey, but it's not Richey,' but it looks like he's looked like that forever – it was just a catwalk moment. And he wasn't embarrassed that he'd morphed into this person overnight, I was just like, 'Fucking hell! Who's given you a makeover?' and he was just like, 'Oh, me.'

KC: *You've got to have some bollocks in a small town I think, to dress like that and to be brave enough to be different.*

JDB: I'd had a few scraps and tumbles in my time, but Nick and Richey weren't of that ilk. I don't think either of them had ever had a fight, so to walk through a town like that, looking like a West Coast androgynous mess with slogans painted all over you, in a hardcore working-class town like Blackwood, where people are stumbling out of the rugby club steaming . . . Yeah, it took a lot of guts, especially when you're not used to getting into fights. It might sound dramatic and it might sound as if I'm trying to give it my own cinematic makeover, but it was! Watching Nick and Richey walk through town with that hair and the eyeliner was kind of startling! Richey had a fearlessness and so did Nick. Nick would just walk through town with his Kylie Minogue T-shirt and his skinny white jeans, with his hair all tousled up, and his eyeliner and necklace and they thought nothing of it when they were told, 'If you walk past like that again you big poof, I'm going to give you a fucking slap.' They didn't care about those things, and yes of course I had the white jeans, and I had a leather jacket, and I had a spray-painted T-shirt, but I had a skinhead so I kind of got away with it – but they didn't . . . So that was a statement of intent there looking back on it.

KC: *Did you deliberately look at what Morrissey was doing? His use of rhetoric, etc.? Every time Morrissey made an outrageous statement he'd be in the music press.*

When Richey would say stuff like, 'We'll always hate Slowdive more than Adolf Hitler' – provocative statements – did you think, 'That's going to get us press'?
I've got to say, we never really talked about it as such. Richey would never ever before an interview say, 'I'm going to say this, I'm going to say that, I'm going to say this,' but Richey was a dedicated scholar. When he was at university, when he was in school, he was always in Blackwood library and I think he studied before he did interviews. He was always prepared, but it was never talked about – you know, 'Guess what I'm going to say?' That never, ever, ever happened.

I do think more than anything that it was growing up in the shadow of people we fucking adored and were influenced by. We all loved the Bunnymen and we saw the way Ian McCulloch talked in interviews. We all loved The Smiths to varying degrees and we saw what Morrissey said in the press. And John Lydon and Mark E. Smith would always shoot from the hip.

We just grew up thinking that was the natural way for musicians to talk, that you were just honest and the interview was kind of an art form. Because people like Mark E. Smith, John Lydon, Ian McCulloch and Morrissey said what they fucking felt and what they thought, so that wasn't us thinking, 'Oh, if we do the same we'll get the same press.' It was just us thinking that's how people who are intelligent conduct themselves in interviews.

KC: *Richey had this appetite for self-destruction and I felt the rock press fed off a lot of the stuff you'd said. Did you feel when he disappeared they should have accepted some responsibility as well?*
JDB: No. No. No I don't, no. We all grew up loving Joy Division and Iggy Pop and for us reading those interviews, listening to those lyrics, just watching footage of all those people and what they created was just absolute pleasure and joy to us. It gave meaning to our lives and shaped us. We were too young and we always thought that Richey would drag himself back from this and he never did. I don't think the music press has got to look upon itself and take any blame because I don't think there's any to be had.

KC: *And did you think that because you'd immersed yourself in all the iconography that you were living in this kind of fictional, fantasy world, and then suddenly it became a reality?*
JDB: Of course, for us we weren't living in a fiction. It was the way we taught ourselves to view the world. But yes, it was a tipping-point. When Richey went missing, suddenly you realise that your friend is one day going

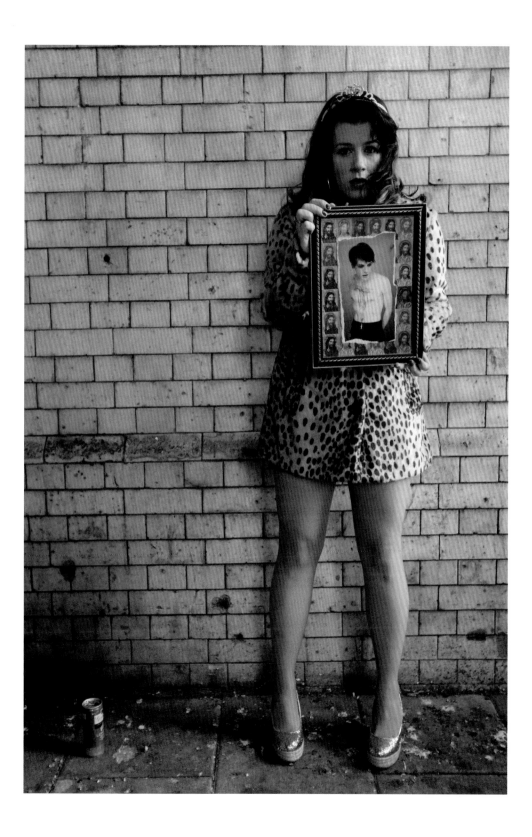

to become a T-shirt, or a byword for some romantic lost mythic vision of what rock 'n' roll should be. You realise that your friend is one day, before your eyes, going to become a myth. So when reality falls and stumbles into myth . . . the myth-making machine . . . it is the strangest feeling of all time, definitely.

KC: *And then intellectually and artistically, where did you think you could go? With Joy Division, they had to become another band. Did you think you might have to become another band?*
JDB: We did for a while, yes, and we definitely toned it down. As soon as Richey went missing, we realised the visual symmetry of the band was dead to a certain degree, and there was no way we could be that symmetrical portion of the band where there were two flying wingers and the stoicism shot through the middle. That was gone, it's as simple as that. So that was one of the first things we tried to tackle, because we just thought, 'Well, we've got to try and make a more musical record, and we've got a choice to try and breathe as a musical band,' rather than be this kind of manifesto flat-pack.

We wondered if the band could exist without the visual splendour that Richey gave us – in tandem with Nick I must say – and we did wonder whether we could still have the same power as a band without Richey. That was one of the first things that really came to mind when we stepped into the rehearsal room after he'd disappeared, which was quite a while after.

KC: *That goes back to your first NME cover, when we put Richey and Nicky on the cover and didn't put you and Sean on there. Because they were so stunning – the pair of them together – I didn't quite think that you two had got your visual identity sorted; you almost looked like two separate bands in a way.*
JDB: Yeah, definitely. A bit like Cheap Trick. I was incredibly close to Richey, but nowhere near as close to him as Nick was. There are little corners within friendships, and I think Nick was his best friend, and it hit us all, but I think it hit Nick really badly when we did the Haçienda warm-up the night before we supported Oasis at Maine Road. I think that really killed him, that gig. Nick was in pieces after it. It just made him realise that he was one half of something that would never be complete again, and that night he was the most distraught I've ever seen him. It took doing an actual gig for it to hit him hard, because I think our first gig without Richey was supporting The Stone Roses, but when we did that Haçienda warm-up it really hit Nick for some reason.

KC: *Yeah, it was very difficult, and then to go on the big stage at Maine Road to do that . . .*

JDB: I'm not saying that feeling went away but the next day we were hit by something else – the fact that people at Maine Road knew 'Design for Life'. We could see there was a crossover – people were just loving singing the lyric 'We just wanna get drunk'. Of course it wasn't in the context of the song itself, but it had crossed over in a weird fucked-up way. That was very much the day after what happened at the Haçienda and it was kind of a nice awakening to be honest; knowing we could be two different bands to two different audiences.

KC: *Michael Sheen said to me 'Libraries gave us power' is one of the greatest lines ever written. Do you know when you write a great line? Because I know when I take a great photograph and I feel really excited about it.*

JDB: Well obviously Nick and Richey were the lyricists, so I know when they have written a great line. It's hit me many times – the first line of 'Motorcycle' when it was 'Culture sucks down words, itemise loathing and feed yourself smiles' just made complete sense to me after years of fucking reading Sartre and *Living Marxism* and stuff like that – I was just like, 'Man, they've done it in one fucking line.' And I remember reading the first line of 'Faster' – 'I am an architect, they call me a butcher' – and I thought, 'Fucking hell, I can't fuck this up, I've got to write some great music to this.' When Nick gave me 'A Design for Life', it was the first time that South Walian, slightly dogged, didactic working-class dignity had come through in one of his lyrics, and it was like, 'No – we've built the working classes in South Wales, we built our own society and we've had to watch you fuckers try and destroy it and now we're coming back again.' It was all distilled in that one line. It's a feeling of fear. When Nick or Richey wrote lyrics that really made me sit bolt upright, I had that fear because I thought, 'I can't fuck this up – I've got to write the best music ever to this.'

KC: *With Joy Division they didn't really know what Ian was writing. I remember Bernard saying to me that after Ian died they looked at his lyrics and they thought, 'Fucking hell, we should have known something was going to happen when we read stuff like this,' but to them it was just another layer of sound.*

JDB: Yeah, I'm sure that they knew there was a bustle in the hedgerow, so to speak. I'm sure they knew, but sometimes when you are presented with words from a great lyricist, if you're properly integrated into a band unit, where you're a gang and you have ambition, the first emotion you have when you're presented with great lyrics is excitement. You don't see into the future, you don't think about the future, you're just completely caught

in the moment. So while I have sympathy for that statement, I wouldn't ever say to them 'Why couldn't you see?' because your first emotion is excitement when you see those words.

KC: *Do you think using quotes from people you admired in your songs was maybe a shortcut to taking you somewhere else?*
JDB: Yeah, it was a full stop for us. It was always just trying to finish a statement, but we felt as if we couldn't do it ourselves. Sometimes it was trying to give something a bit more weight but more often than not it was a clue in a crossword basically.

KC: *Yes, because Brendan Behan once said that 'you should always attribute a quote to somebody else to lend it more credence', and I think Tony Wilson used to do that quite a lot.*
JDB: My god, I mean, Tony . . . you know, he spoke . . . He was a cultural Presbyterian, he just spoke in tongues, he was just taking words out of the air that had already been said and remoulding them himself. That's why I loved him so much. One of our most thrilling moments was when we did 'Suicide Alley', our first indie single, paid for it ourselves and which Swells reviewed in the *NME*. We'd sent it out to lots of people and Richey had sent one of his copies, with a letter, to Tony Wilson's programme *After Midnight*, which we all used to watch – we'd seen The Stone Roses on there – and he read Richey's letter out on one of the programmes and he goes, 'I've a letter here from a young punk, a young surrealist punk from South Wales, talking about how we shouldn't be emblazoning ourselves with corporate logos like Joe Bloggs, and we're lost in a stuttering culture of consumerism, and we're completely and utterly censoring our intelligence by taking these drugs – don't listen to that, listen to this and there's a DIY punk single I've got here, so I'll give it a listen.' I was watching and going, 'I can't believe it, fucking hell, Tony Wilson's read Richey's letter out!' I think Richey loved the fact that Tony Wilson's favourite ever quote was Sid Vicious's:
– Do you care what the man in the street thinks about your music?
– No.
– Why not?
– Because I've met the man in the street, and he's a cunt.

KC: *And Morrissey as well. That's always been Morrissey's big thing, because lots of lines from Morrissey songs also appropriate quotes from literature and other sources.*
JDB: The Morrissey/Marr axis was what attracted us to The Smiths initially because Morrissey/Marr, Jagger/Richards, Strummer/Jones – you knew that they knew that the thrust of their band, whilst being groundbreaking,

had to be classic as well. They weren't stupid, they realised they were classicists –The Smiths, Morrissey and Marr – and the way they pushed their songwriting partnership to the front of the band was essential really.

KC: *Seven years after Richey's disappearance when he'd been declared dead, did you feel that the band was then able to move on and become something different?*
JDB: I think we clung on to each other for *Everything Must Go* and we realised that there were still three of us. Not only were we bandmates, but we'd been friends all our lives and one of us just wasn't there anymore. There was stuff that was still too precious for us to let go. We didn't think of how incomplete we were without Richey, we just clung on to each other and went forward, and I think we did become a different band straight away on *Everything Must Go*. On *Everything Must Go* you still have some of Richey's lyrics – you've still got 'Kevin Carter', you've still got 'The Girl Who Wanted to Be God', 'Small Black Flowers That Grow in the Sky', 'Elvis Impersonator: Blackpool Pier' on there. You've still got Richey's lyrics on there, but it just shows the direction we would have gone in if Richey had still been in the band, because he'd heard some of those songs before he went missing.

But we would have definitely still gone in that direction regardless. It felt like at the end of *Everything Must Go*, it took a long time for us to realise that that version of the band had existed longer than the version Richey had been in.

Essentially, Richey had only been in the band for three albums, and by the time we'd got to *Postcards* we'd done seven albums without him. It's a gradual thing, but I think for us to actually survive, we had to become another version of ourselves immediately, and that's what happened with *Everything Must Go*, I think.

KC: *When we went to Bangkok for that chaotic few days, you said you thought Richey looked at his most beautiful there . . .*
JDB: The only way I can describe it is I think he kept his innocence whilst absorbing as much as he could. On the surface it didn't seem like he was being a cipher for knowledge and experience, but it didn't seem as if it was damaging his innocence on the outside. Because in those pictures – especially in one of my favourites, where he's sat down outside some kind of massage parlour – he still looks like he's open to the world but not destroyed by it.

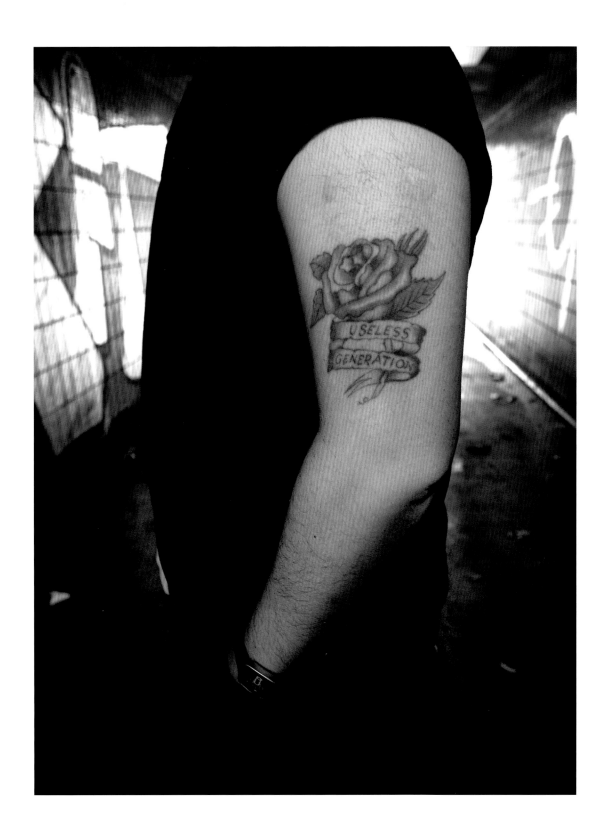

KC: *Absolutely.*

JDB: Obviously that's not the way it seems it panned out, but that's what I love about that picture: he's not degraded by experience, he just feels as if he's learned from it. It looks in that picture – and there's still a lovely innocence there – like he could be many things: he could be the person you sat down and watched the rugby and the boxing with, or he could be the person that would talk in riddles, or he could be the person that was just cute and cuddly and just laughed. Or sometimes he could be quite blunt, and upsetting and in that picture it's just the good side of Richey. I see the side which is just fiercely intelligent to the core and just open to being an artist.

He was an intellectual. I've never had an intellectual moment in my life. I've had creative moments, but no intellectual moments, I don't think, whereas his experience was constantly intellectual, and you see it in that picture. But you also see a human side to him as well, and he just looks physically beautiful, that's the bottom line – he looks physically beautiful in that photo.

KC: *And then there's the shot of him clinging onto the statue. That was possibly among the last set of pictures taken of him wasn't it?*

JDB: The change between what I think is one of the best photos of him of all time in Thailand, outside the massage parlour, and the picture down in Bluestone in Wales with that statue is marked, just absolutely, it's almost like he's cut the cord. Between those two pictures he's cut the cord between a version of himself . . . he's cast it adrift . . . he's just turned into something else, he's suddenly become a person that none of us could quite reach.

KC: *Well it was a difficult shot, because he was wearing a vest and you can see all the self-harming on his arm. There are lots of cuts and lots of cigarette burns as well.*

JDB: I think back to those times and I think, 'Why didn't we see the gathering storm,' but we were still in thrall to the canon of visual work that Iggy Pop had done, and people like that. You know, we still felt as if we were just part of rock 'n' roll expressionism, I suppose.

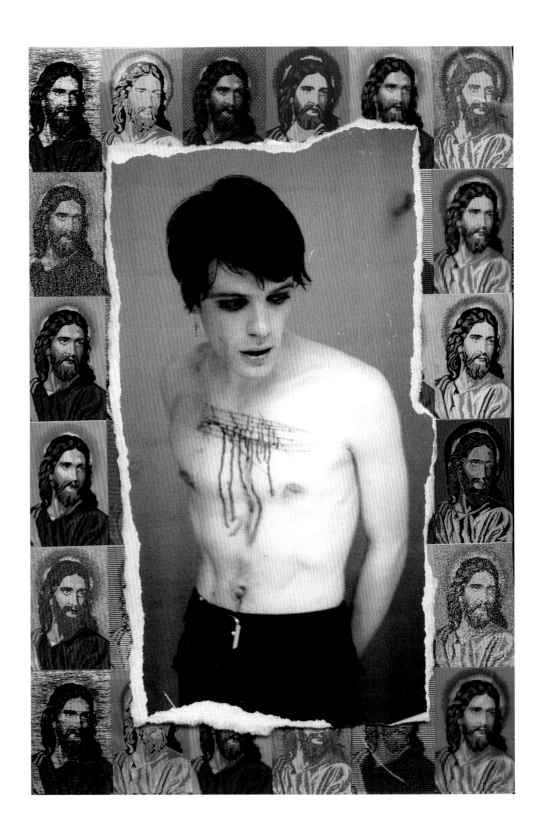

Locations and Dates

First published in 2014
by Faber & Faber Ltd
Bloomsbury House
74–77 Great Russell Street
London WC1B 3DA

Designed by Friederike Huber
Printed in China by C&C Offset Printing Co. Ltd

A CIP record for this book
is available from the British Library

ISBN 978–0–571–31213–9
LIMITED EDITION ISBN 978–0–571–31215–3

10 9 8 7 6 5 4 3 2 1